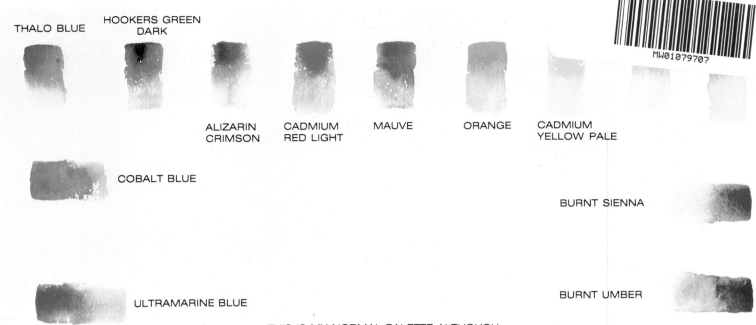

THALO BLUE
HOOKERS GREEN DARK
ALIZARIN CRIMSON
CADMIUM RED LIGHT
MAUVE
ORANGE
CADMIUM YELLOW PALE

COBALT BLUE

BURNT SIENNA

BURNT UMBER

ULTRAMARINE BLUE

THIS IS MY NORMAL PALETTE ALTHOUGH I MAY ADD OTHER COLORS FOR SPECIAL PAINTINGS.

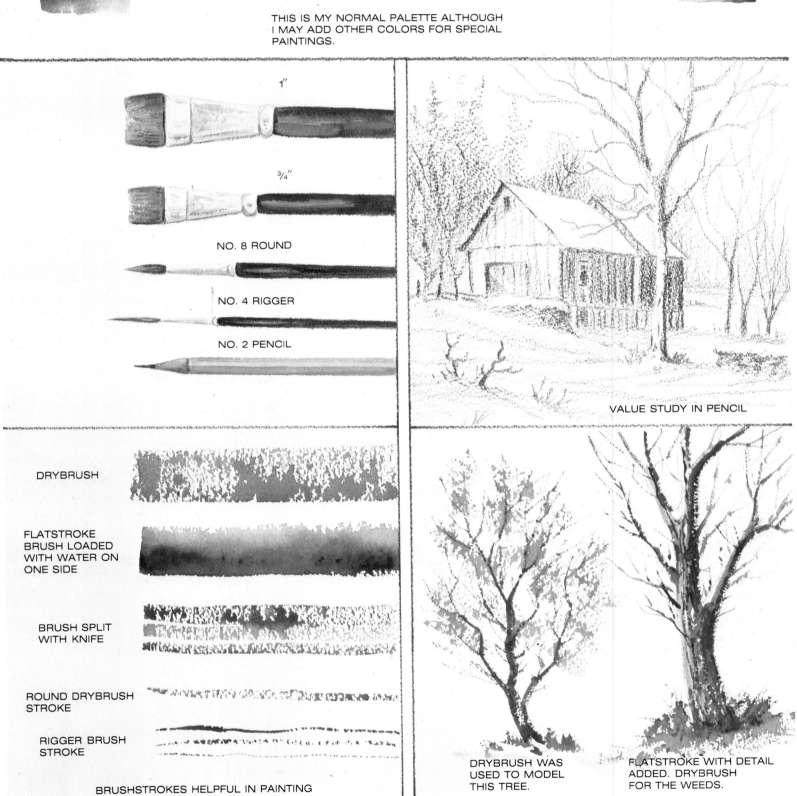

1"
3/4"
NO. 8 ROUND
NO. 4 RIGGER
NO. 2 PENCIL

VALUE STUDY IN PENCIL

DRYBRUSH

FLATSTROKE BRUSH LOADED WITH WATER ON ONE SIDE

BRUSH SPLIT WITH KNIFE

ROUND DRYBRUSH STROKE

RIGGER BRUSH STROKE

BRUSHSTROKES HELPFUL IN PAINTING

DRYBRUSH WAS USED TO MODEL THIS TREE.

FLATSTROKE WITH DETAIL ADDED. DRYBRUSH FOR THE WEEDS.

1

FLATWASH

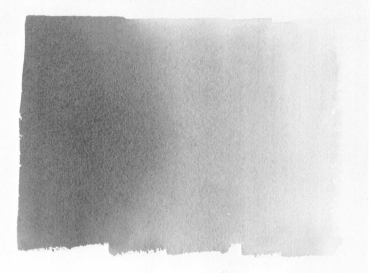

GRADED WASH

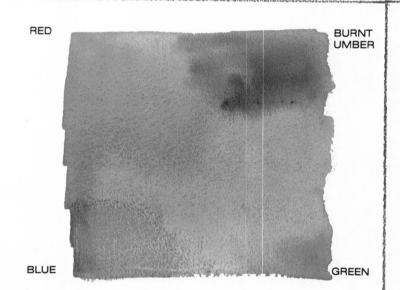

RED

BURNT
UMBER

BLUE

GREEN

DIFFERENT COLORS WERE DROPPED
INTO THE WET WASH AND ALLOWED
TO MINGLE TOGETHER.

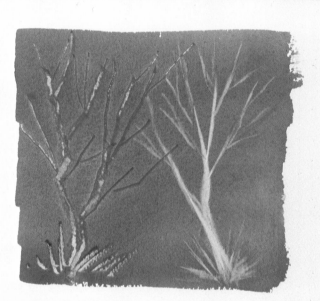

THE TREE WAS SCRAPED
WITH A KNIFE WHILE
THE WASH WAS WET.

COLOR LIFTED
WITH A SEMI-
DRY BRUSH.

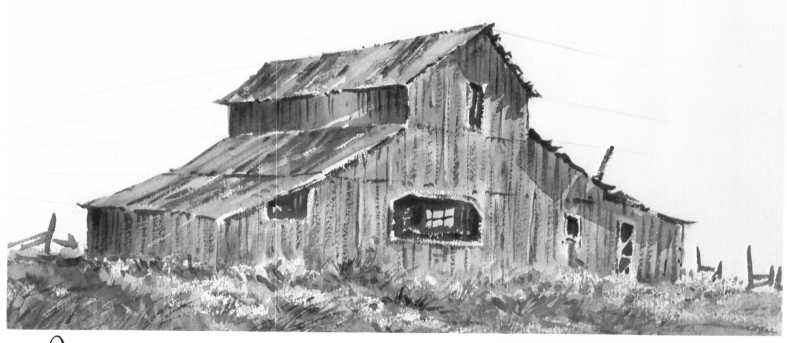

\mathcal{I} used the combined techniques (shown above and on page three) to paint this barn. A few perspective lines were added.

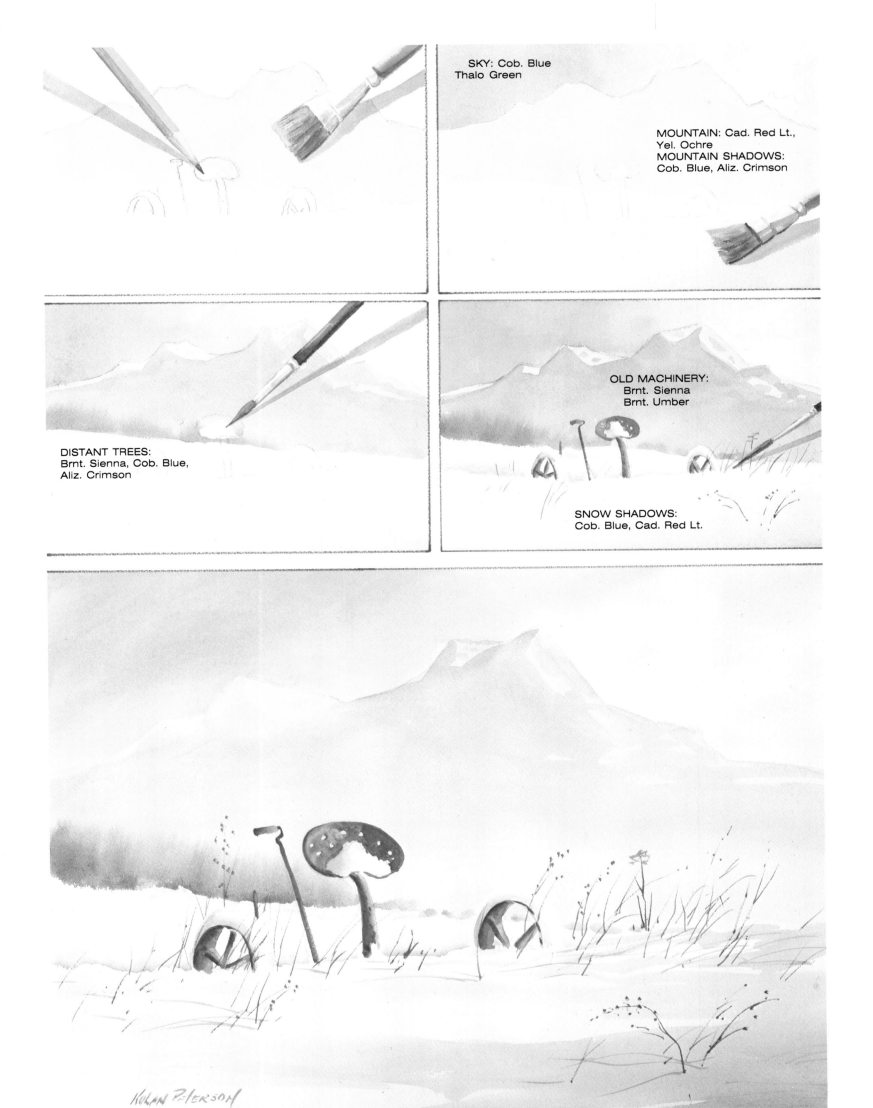

SKY: Cob. Blue
Thalo Green

MOUNTAIN: Cad. Red Lt.,
Yel. Ochre
MOUNTAIN SHADOWS:
Cob. Blue, Aliz. Crimson

DISTANT TREES:
Brnt. Sienna, Cob. Blue,
Aliz. Crimson

OLD MACHINERY:
Brnt. Sienna
Brnt. Umber

SNOW SHADOWS:
Cob. Blue, Cad. Red Lt.

DERELICT – Ever see a scene like this when you were driving across the country on a winter's day? Simple things like this rusted old hay rake tells you summer is gone and the farmer is warm and cozy in his home. Note how weeds in foreground eliminate monotony. So the simplest landscapes do turn out best. Practice doing large flat washes such as those that are done in the sky, the mountains and drifting snow.

ROCK FORMATION:
Yel. Ochre, Sap Green,
Brnt. Sienna, Brnt. Umber
Cob. Blue, Aliz. Crimson

SAND: Yel. Ochre,
Brnt. Sienna, Cob. Blue

WATER: Yel. Ochre,
Raw Umber, Cob.
Blue, Aliz. Crimson

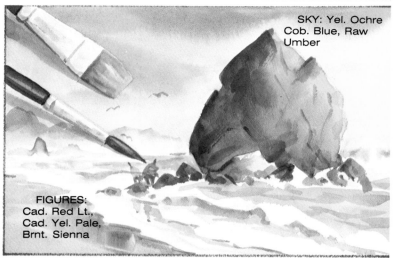

SKY: Yel. Ochre
Cob. Blue, Raw
Umber

FIGURES:
Cad. Red Lt.,
Cad. Yel. Pale,
Brnt. Sienna

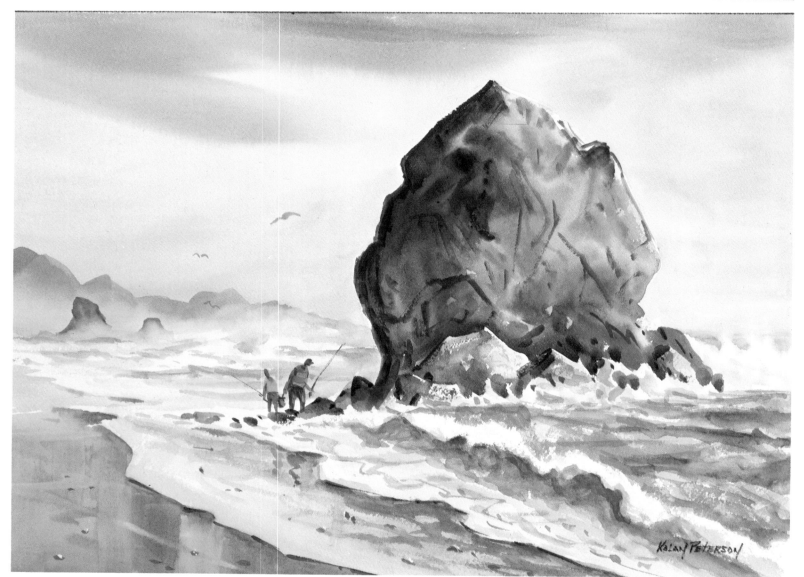

NEAR MORRO BAY – From pencil sketch to final painting, this Morro Bay scene just had to turn out good. The scene popped out at you as you "cased" the beach for a subject and you just had to paint it. This is a definite mood painting. The wild sea buffeting a sturdy rock makes its point the moment you see it. Fishermen add life to an already lively seascape. These are items you will want to notice: The play of colors on the rock. On the right, the white water slaps against the rock. How do you achieve this foamy effect? You merely paint around the white foam area and soften the edge with a damp brush. Where the wave invades the beach on the left side of picture, the russet sand is given the wet look by painting in some vertical streaks with your big brush. The light streak was also lifted out with a damp brush.

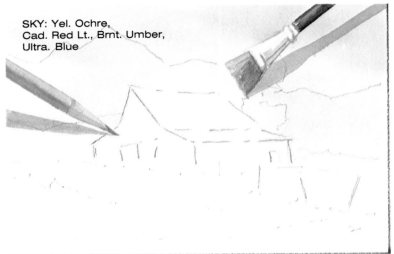

SKY: Yel. Ochre,
Cad. Red Lt., Brnt. Umber,
Ultra. Blue

MOUNTAINS: Cob. Blue,
Aliz. Crimson

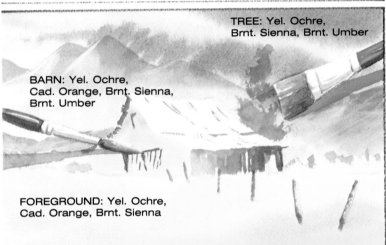

TREE: Yel. Ochre,
Brnt. Sienna, Brnt. Umber

BARN: Yel. Ochre,
Cad. Orange, Brnt. Sienna,
Brnt. Umber

FOREGROUND: Yel. Ochre,
Cad. Orange, Brnt. Sienna

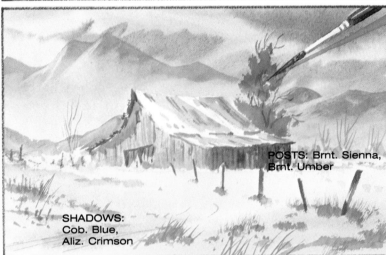

POSTS: Brnt. Sienna,
Brnt. Umber

SHADOWS:
Cob. Blue,
Aliz. Crimson

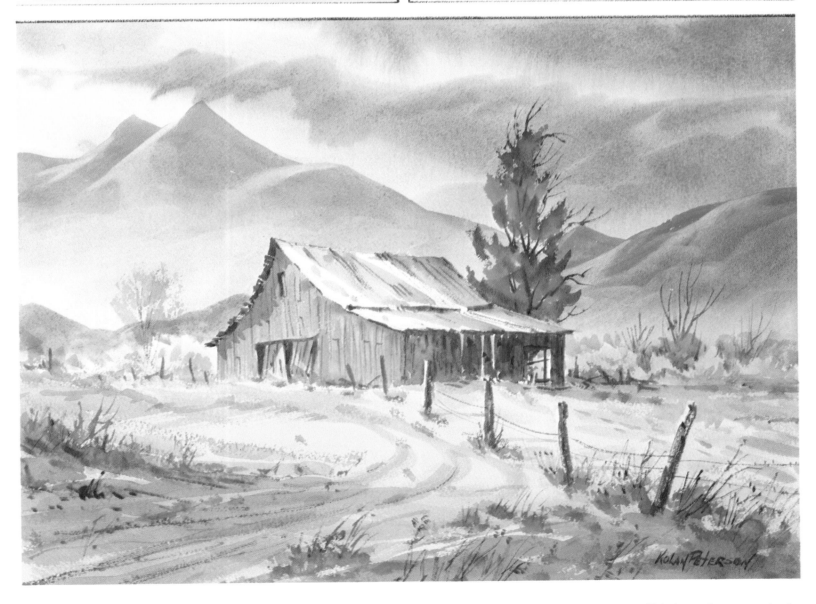

APPROACHING STORM – Barns continue to dot the American landscape, although in diminishing numbers. This is another example of a survivor that you like to see around. You can feel the mood of the approaching storm as it comes in over the mountains. It's a good idea to keep the area in front of the barn light. It allows you to use light to emphasize dark. The dark shadows in the lower part of picture push your eyes up to the barn as do the sweeping lines of the road. Notice light bushes coming through to left and right of structure. It's a good touch you can use. Whispy tree is dry-brushed in. Fences and tree in back of barn add to finished effect.

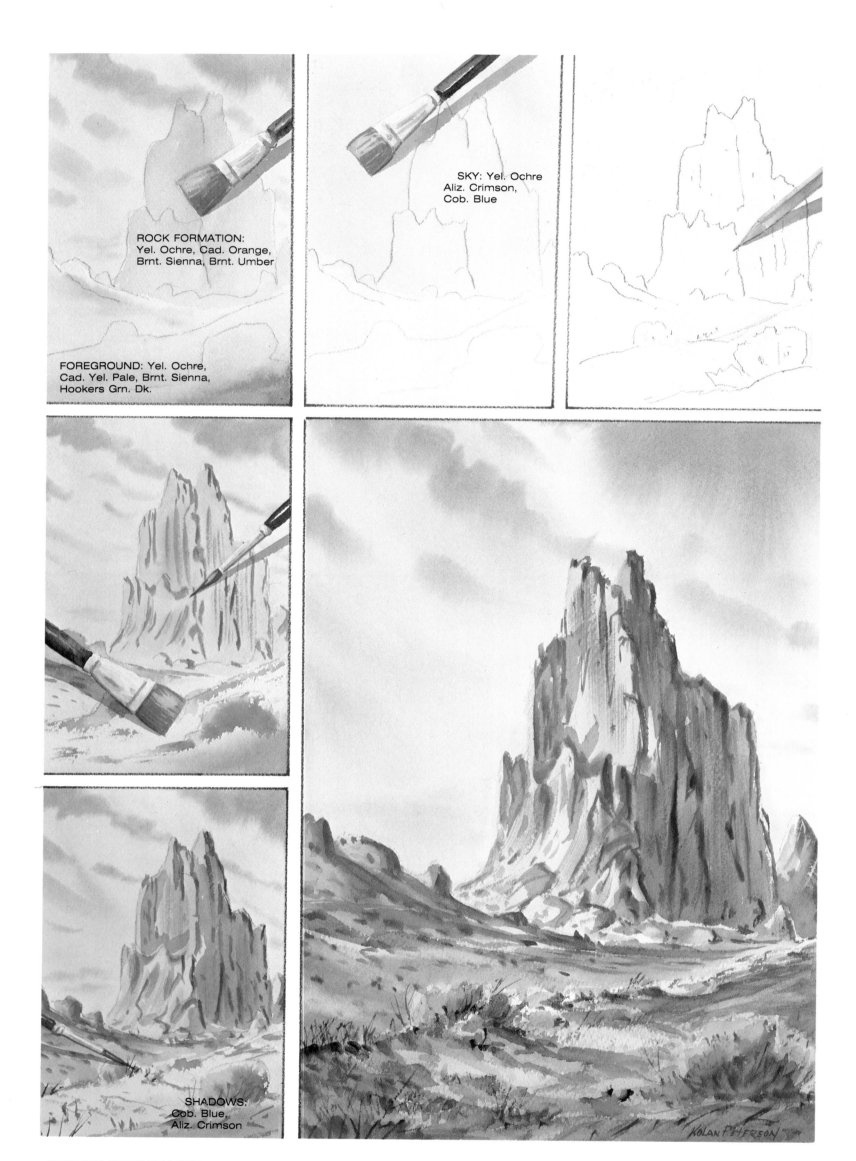

ROCK FORMATION:
Yel. Ochre, Cad. Orange,
Brnt. Sienna, Brnt. Umber

FOREGROUND: Yel. Ochre,
Cad. Yel. Pale, Brnt. Sienna,
Hookers Grn. Dk.

SKY: Yel. Ochre
Aliz. Crimson,
Cob. Blue

SHADOWS:
Cob. Blue,
Aliz. Crimson

DESERT SKYSCRAPER – Mountains should stand tall and challenging against an ample sky. Using "Shiprock" as a theme for this desert picture, it dares a foreboding stormy sky (done in wet on wet technique) to do its utmost to wash it off the landscape. Notice that light comes from left. Shadow on dark side of mountain is a glaze of cobalt with just a touch of alizarin. It is applied after picture is dry. Middle and foreground desert terrain add wildness that is inherent in this kind of picture.

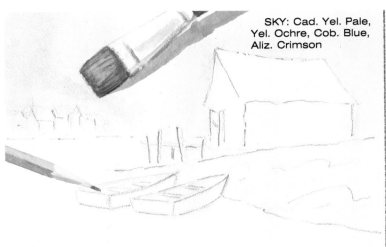

SKY: Cad. Yel. Pale, Yel. Ochre, Cob. Blue, Aliz. Crimson

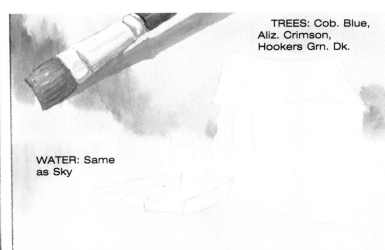

TREES: Cob. Blue, Aliz. Crimson, Hookers Grn. Dk.

WATER: Same as Sky

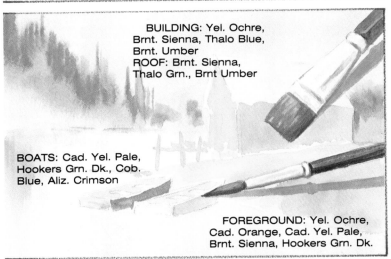

BUILDING: Yel. Ochre, Brnt. Sienna, Thalo Blue, Brnt. Umber
ROOF: Brnt. Sienna, Thalo Grn., Brnt Umber

BOATS: Cad. Yel. Pale, Hookers Grn. Dk., Cob. Blue, Aliz. Crimson

FOREGROUND: Yel. Ochre, Cad. Orange, Cad. Yel. Pale, Brnt. Sienna, Hookers Grn. Dk.

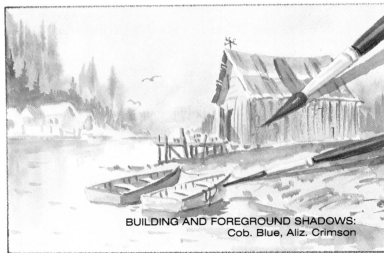

BUILDING AND FOREGROUND SHADOWS: Cob. Blue, Aliz. Crimson

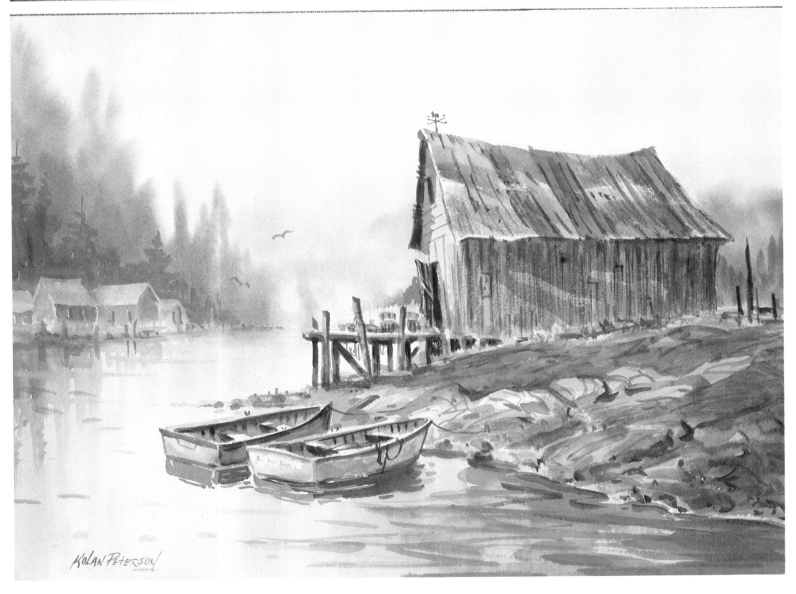

CALM HARBOR – A good picture deserves a good name. Calm Harbor sets the scene for this work. Sun burning through the morning mists creates beautiful, illusory shadows. You can feel the dampness of early morning in the air and the misty dwellings on the far side emphasize the chill. Distant trees are painted in while the paper is wet. Shack lends character to scene and the boats beckon the viewer to share an adventure. Keep water light and then you can add reflections to impart the feeling of wetness. Shack is done with dry brush and split brush technique.

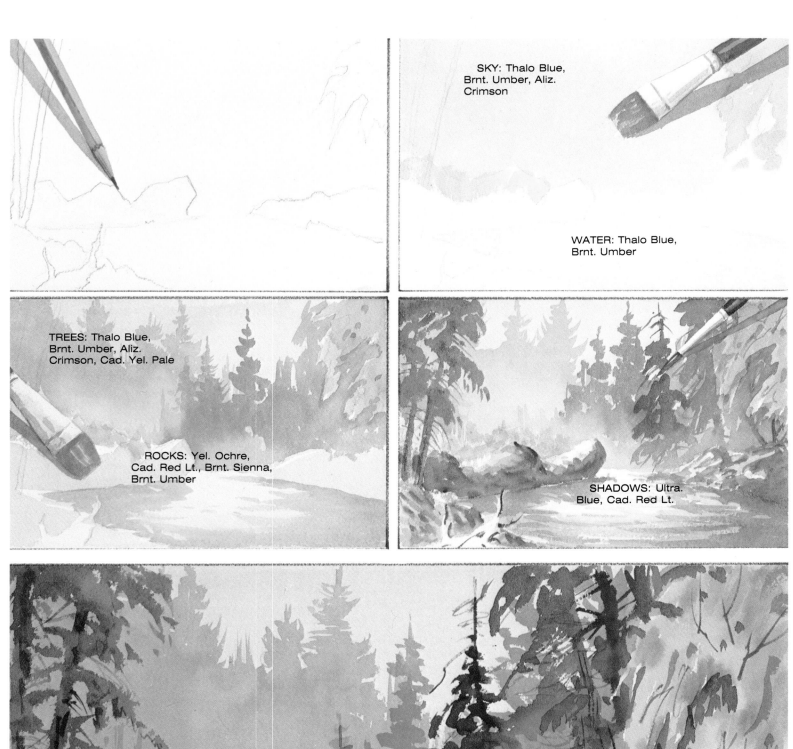

SKY: Thalo Blue, Brnt. Umber, Aliz. Crimson

WATER: Thalo Blue, Brnt. Umber

TREES: Thalo Blue, Brnt. Umber, Aliz. Crimson, Cad. Yel. Pale

ROCKS: Yel. Ochre, Cad. Red Lt., Brnt. Sienna, Brnt. Umber

SHADOWS: Ultra. Blue, Cad. Red Lt.

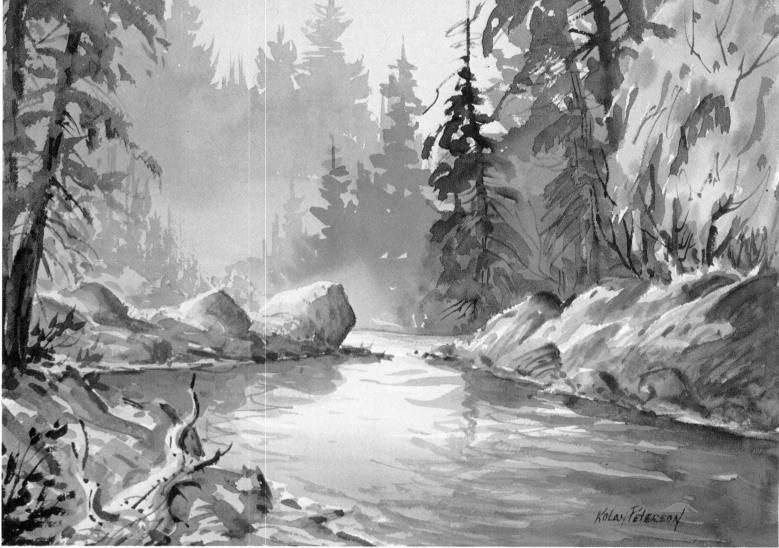

MISTY RIVER – Large masses of trees are a problem for most students. The procedure is simple. Paint in the overall mass and then pull out trees in shadowy back area. Increase intensity as you come forward with your painting and you will accomplish a pleasing effect. Notice light on rocks comes from left. Trees in foreground right are "shaded" into picture with darker colors. This imparts distance. Water is introduced in lighter color and glistening shadows and reflections make you feel the flow of the stream. You can add fishermen into the picture or better still, get out your rod and reel and head for a stream you know. The trout are hitting good this year.

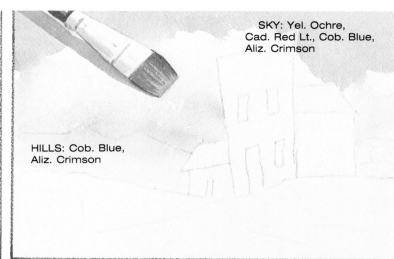

SKY: Yel. Ochre,
Cad. Red Lt., Cob. Blue,
Aliz. Crimson

HILLS: Cob. Blue,
Aliz. Crimson

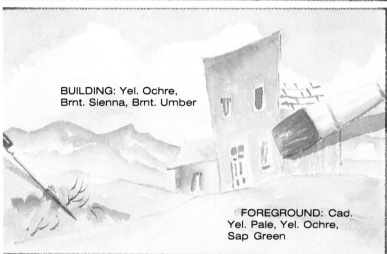

BUILDING: Yel. Ochre,
Brnt. Sienna, Brnt. Umber

FOREGROUND: Cad.
Yel. Pale, Yel. Ochre,
Sap Green

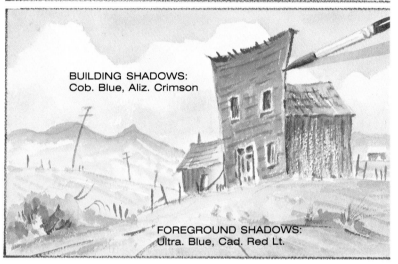

BUILDING SHADOWS:
Cob. Blue, Aliz. Crimson

FOREGROUND SHADOWS:
Ultra. Blue, Cad. Red Lt.

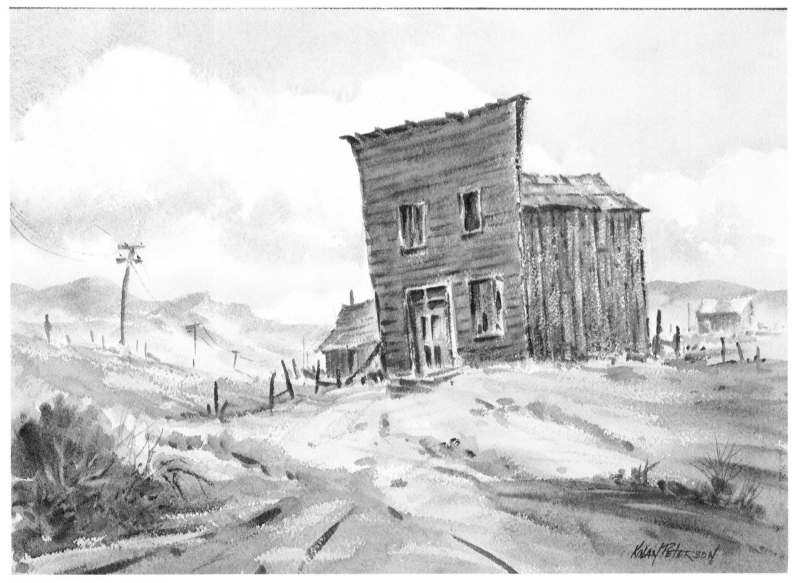

GHOST TOWN OLD TIMER — The building tilts and leans because of the prevailing winds that have blown against it for years. Old buildings had false fronts to make them look three stories high. Dry brush technique is used to give character to the structure. Cloudy foreboding sky was painted around the building. Notice that this is an entirely different sky. The shadows, you will observe, are added underneath the lighter portions of the clouds. Fence posts lead you down the road. Power lines might indicate a rebirth is coming but the foreground is still wild and delightful. Notice light area in front of building uses light against dark to emphasize the structure's place in the scheme of things. Sloping of hills and mountains to left lead viewer's eyes to the decaying store.

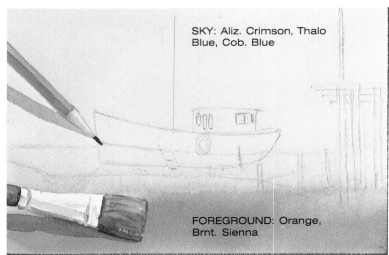

SKY: Aliz. Crimson, Thalo Blue, Cob. Blue

FOREGROUND: Orange, Brnt. Sienna

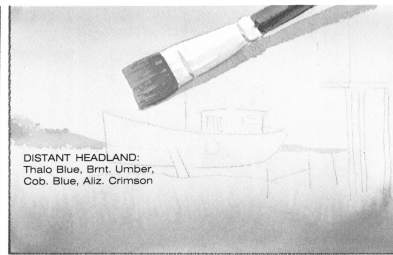

DISTANT HEADLAND: Thalo Blue, Brnt. Umber, Cob. Blue, Aliz. Crimson

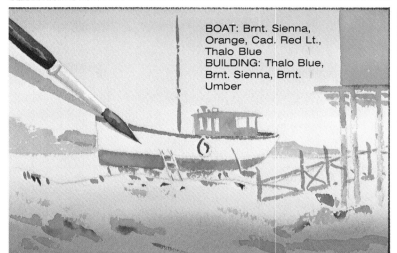

BOAT: Brnt. Sienna, Orange, Cad. Red Lt., Thalo Blue
BUILDING: Thalo Blue, Brnt. Sienna, Brnt. Umber

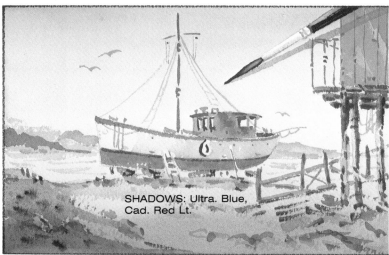

SHADOWS: Ultra. Blue, Cad. Red Lt.

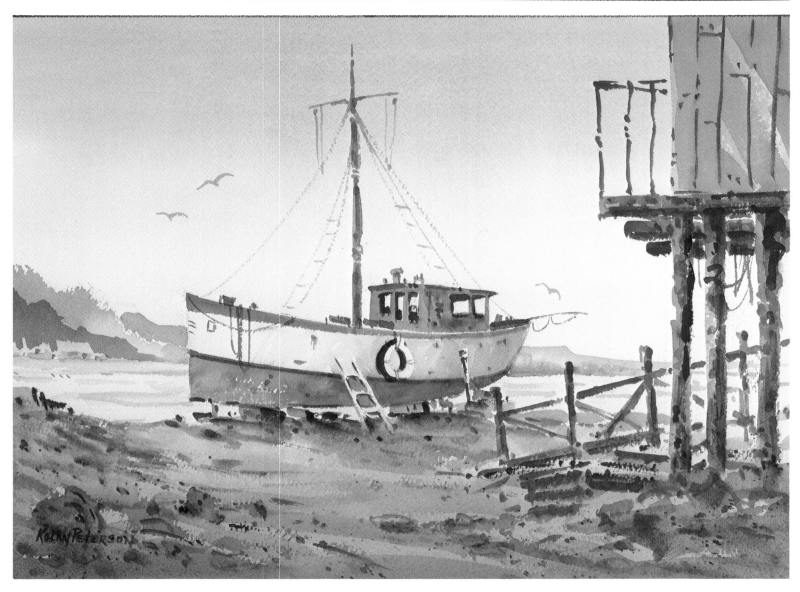

SNUG HARBOR – Could be any place along a seacoast. Notice that the sky is done in graded wash. The water is light with just a few indicated ripples. Note the graded wash that is applied to the hull of the boat. It shows that light is coming from left. Structure on right drives your eyes out to sea through use of heavy colors. Trash, old timbers (done in a form of dry brush) break up beach mass. To add effect to the foreground strew it with rocks, plants and slanting shadows. The sky and the foreground were done in graded washes. See first illustration. This is so important that it is being repeated for your consideration here. Life is achieved through the introduction of gulls in flight.

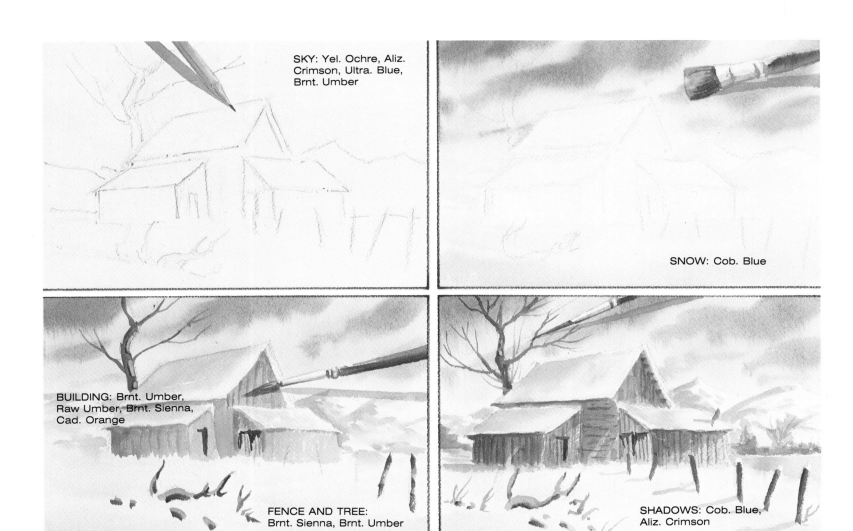

SKY: Yel. Ochre, Aliz. Crimson, Ultra. Blue, Brnt. Umber

SNOW: Cob. Blue

BUILDING: Brnt. Umber, Raw Umber, Brnt. Sienna, Cad. Orange

FENCE AND TREE: Brnt. Sienna, Brnt. Umber

SHADOWS: Cob. Blue, Aliz. Crimson

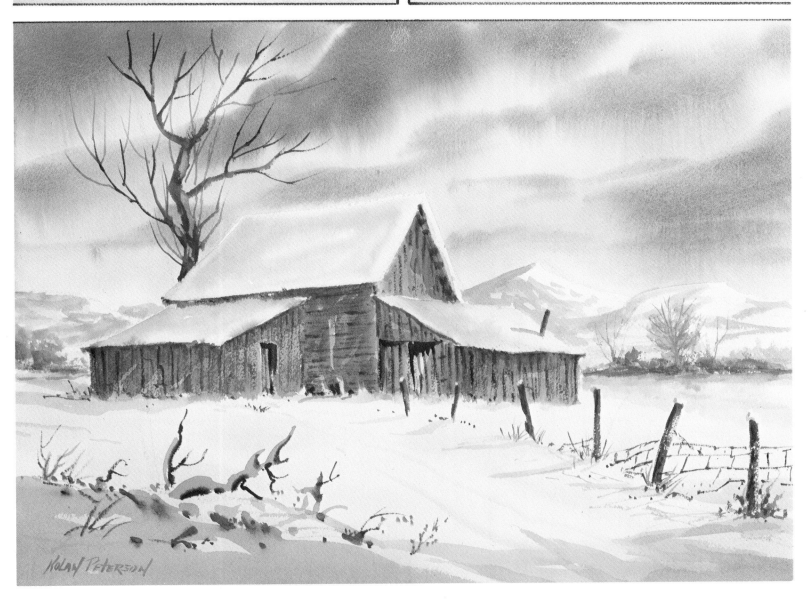

Nolan Peterson

UTAH CHILDHOOD SCENE – I spent my childhood in Utah. Fond memories are shown in this picture. It brings back the cold, crisp mornings when snow blanketed the landscape. I painted the sky wet in wet and I was careful to save the shapes of the roofs, which were toned later. Paint the washes on the building and add detail and shadows later. (See steps in sketches above.) Fenceposts were done with dry brush. Shadows at bottom foreground balances the painting. Highlights on tree were scraped out with a knife.

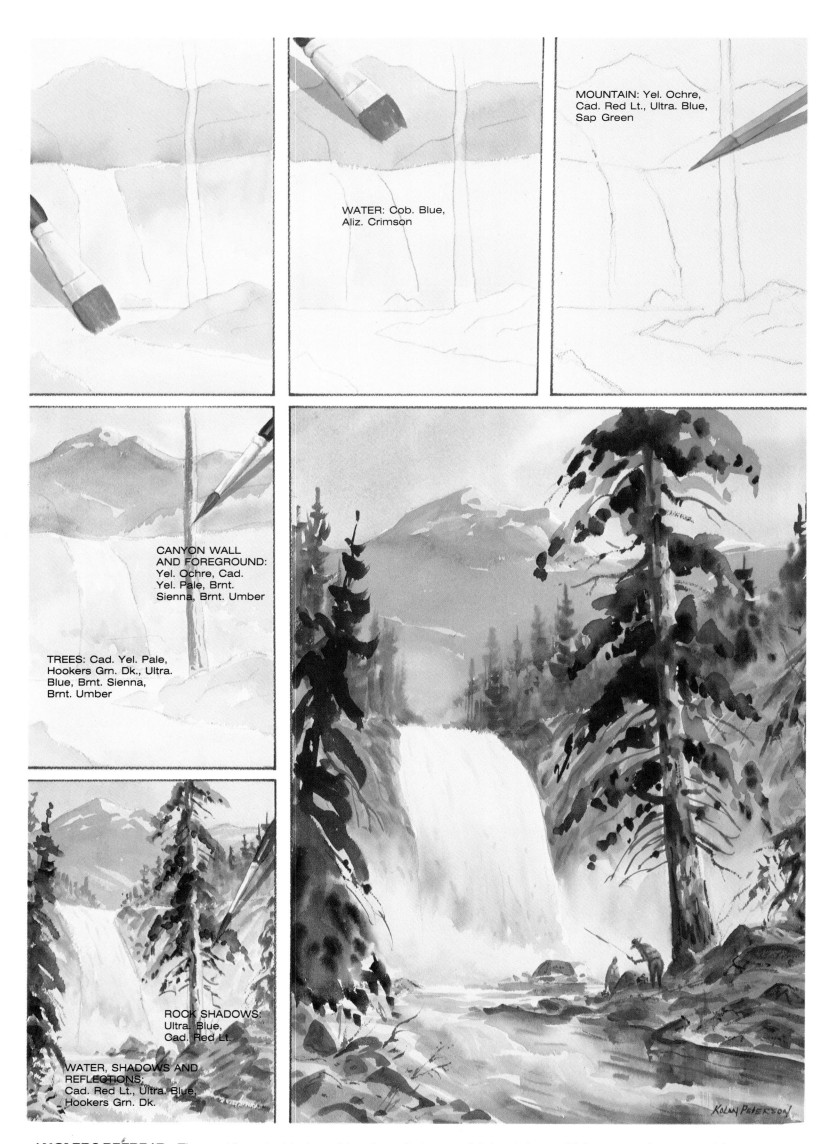

MOUNTAIN: Yel. Ochre, Cad. Red Lt., Ultra. Blue, Sap Green

WATER: Cob. Blue, Aliz. Crimson

CANYON WALL AND FOREGROUND: Yel. Ochre, Cad. Yel. Pale, Brnt. Sienna, Brnt. Umber

TREES: Cad. Yel. Pale, Hookers Grn. Dk., Ultra. Blue, Brnt. Sienna, Brnt. Umber

ROCK SHADOWS: Ultra. Blue, Cad. Red Lt.

WATER, SHADOWS AND REFLECTIONS: Cad. Red Lt., Ultra. Blue, Hookers Grn. Dk.

ANGLERS RETREAT – The most important feature of the picture is the waterfall. Its motion and lightness catch your eye right away. Note water's treatment on stream below falls. Tone the white paper just a little and add a few vertical lines to give movement to the falls. Mist was created by the use of more clean water added at the area behind the big tree. The mountain's big shape is a foil for the waterfall. Small branches are done with the rigger brush. Fishermen in this painting tell a story of a good day on the stream. You might want to remember the complimentary color scheme in this picture for some painting you will be doing in the future.

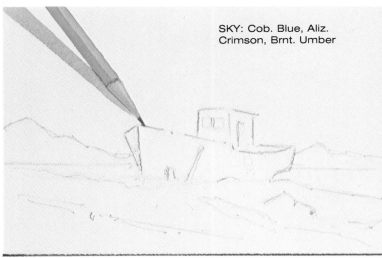

SKY: Cob. Blue, Aliz. Crimson, Brnt. Umber

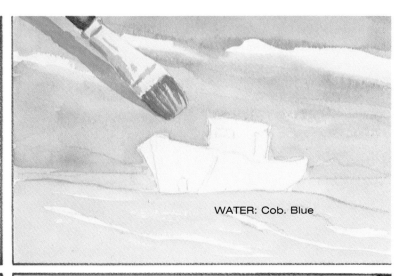

WATER: Cob. Blue

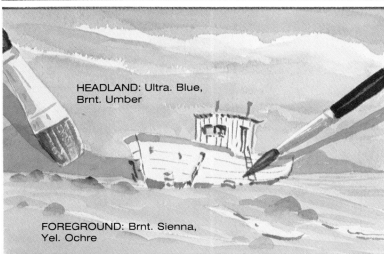

HEADLAND: Ultra. Blue, Brnt. Umber

FOREGROUND: Brnt. Sienna, Yel. Ochre

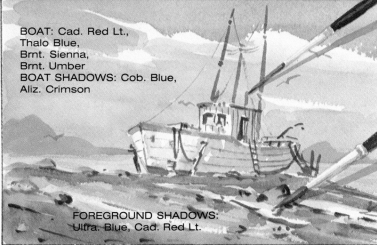

BOAT: Cad. Red Lt., Thalo Blue, Brnt. Sienna, Brnt. Umber
BOAT SHADOWS: Cob. Blue, Aliz. Crimson

FOREGROUND SHADOWS: Ultra. Blue, Cad. Red Lt.

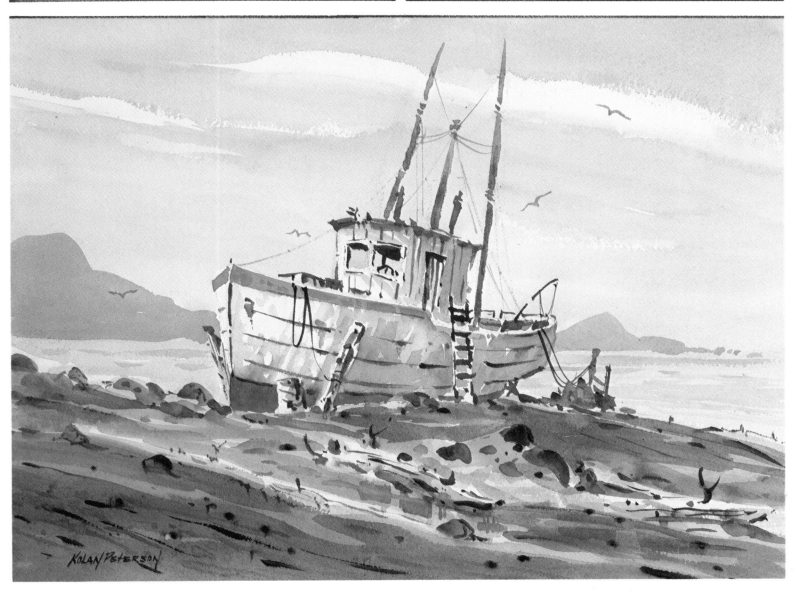

BEACHED FOR REPAIRS – Sometimes it is best to use white paper in your color scheme. This boat presents just such an example. No white paint is ever used in transparent watercolor, at least it shouldn't be. You simply use the white of the paper. Shadow details were added to bring out the boat's form. Notice that a graded wash was used to give roundness to the hull and to force the viewer to look to the light focal point, which in this case is the prow of the boat. Ground surface color imparts a reflected light to pique the viewer's eye. It's really a happy shadow pattern that is not just happenstance.

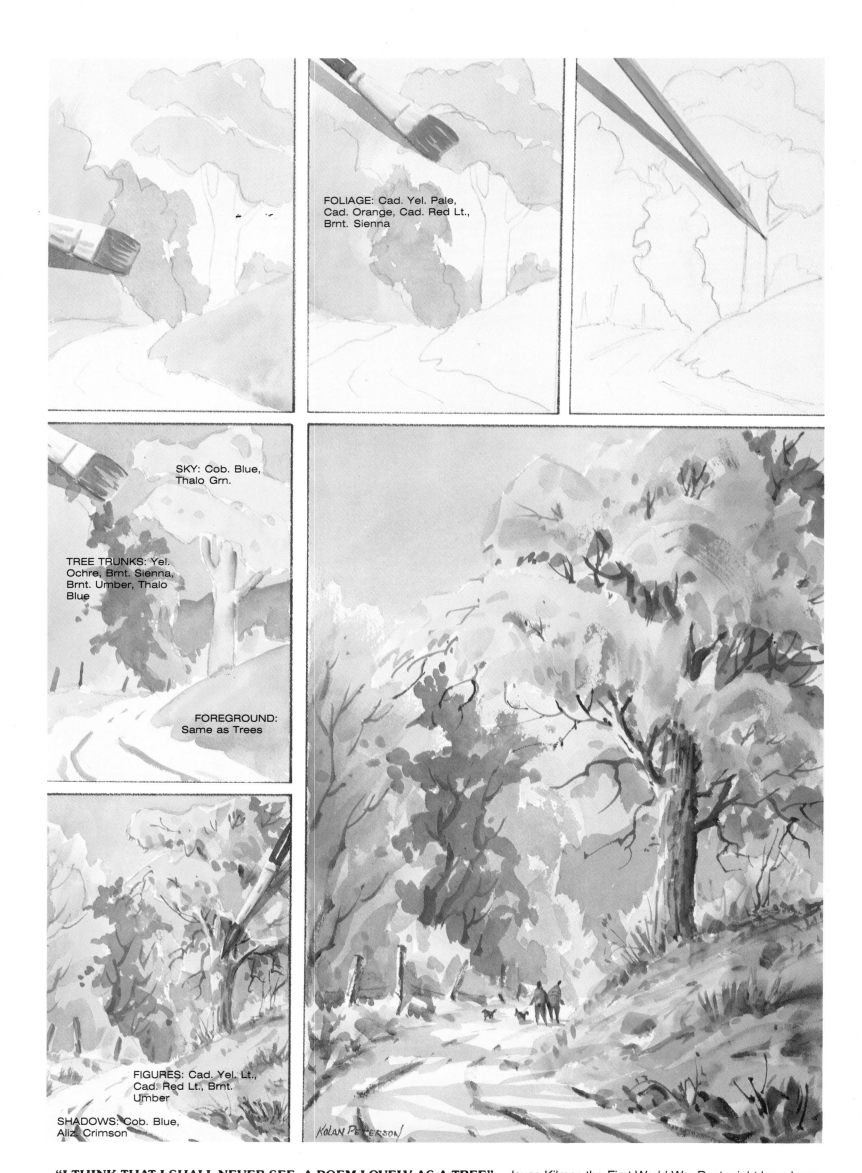

FOLIAGE: Cad. Yel. Pale,
Cad. Orange, Cad. Red Lt.,
Brnt. Sienna

SKY: Cob. Blue,
Thalo Grn.

TREE TRUNKS: Yel.
Ochre, Brnt. Sienna,
Brnt. Umber, Thalo
Blue

FOREGROUND:
Same as Trees

FIGURES: Cad. Yel. Lt.,
Cad. Red Lt., Brnt.
Umber

SHADOWS: Cob. Blue,
Aliz. Crimson

KolaN PeTerson

"I THINK THAT I SHALL NEVER SEE, A POEM LOVELY AS A TREE" – Joyce Kilmer, the First World War Poet might have been writing about this lovely specimen. The picture is done in a pleasing loose style and it emphasizes color masses against a cool green sky. Note the treatment of trunk in foreground tree. A few cast shadows establish roundness. The strolling couple and their dogs are an important part of the composition. Wouldn't you like to walk in this wonderland of fall colors? Don't forget to paint in the shadow patterns in the foreground. They will definitely help "finish" the picture.

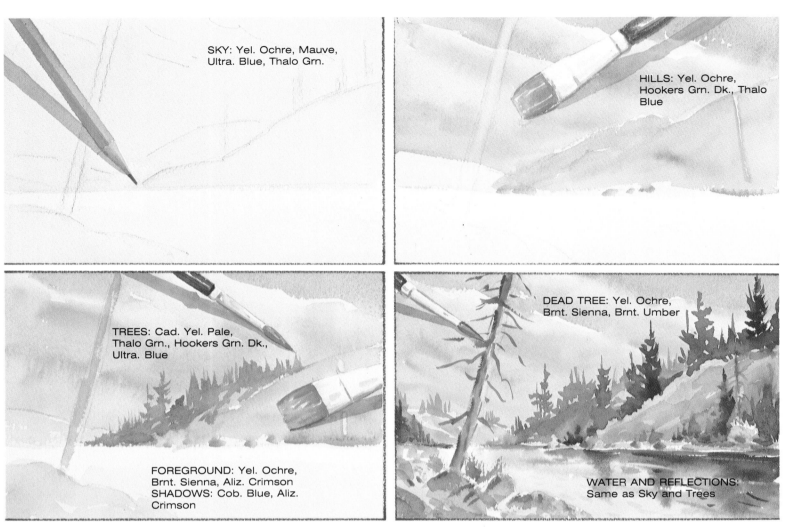

SKY: Yel. Ochre, Mauve, Ultra. Blue, Thalo Grn.

HILLS: Yel. Ochre, Hookers Grn. Dk., Thalo Blue

TREES: Cad. Yel. Pale, Thalo Grn., Hookers Grn. Dk., Ultra. Blue

FOREGROUND: Yel. Ochre, Brnt. Sienna, Aliz. Crimson
SHADOWS: Cob. Blue, Aliz. Crimson

DEAD TREE: Yel. Ochre, Brnt. Sienna, Brnt. Umber

WATER AND REFLECTIONS: Same as Sky and Trees

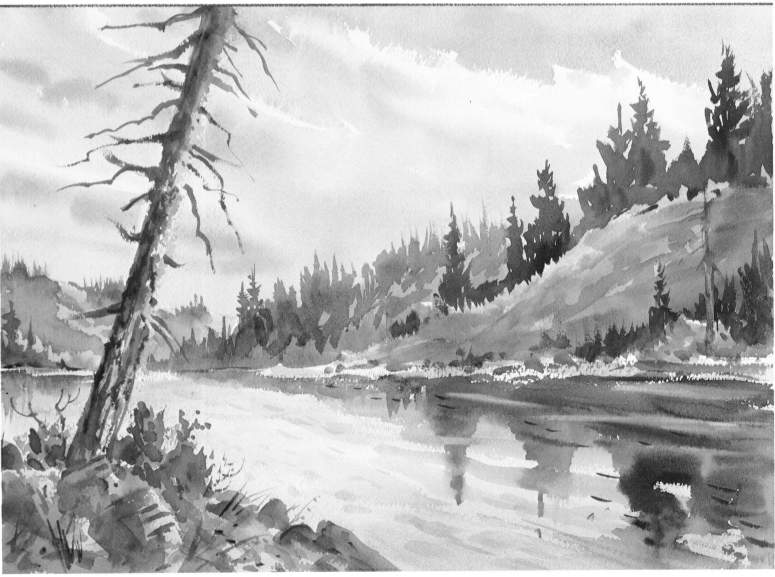

UP A LAZY RIVER? Not quite. This is one that was done on a fishing jaunt on Hemet Lake. The sky makes you "feel" the cool of the evening. The dead tree avoids monotony and keeps your eye from going out of the picture. Reflection in the water was done with the large brush and with the utmost simplicity and then you "lift" out ripples with the same large brush to make water come through to viewer's eye just as he would see it in nature.

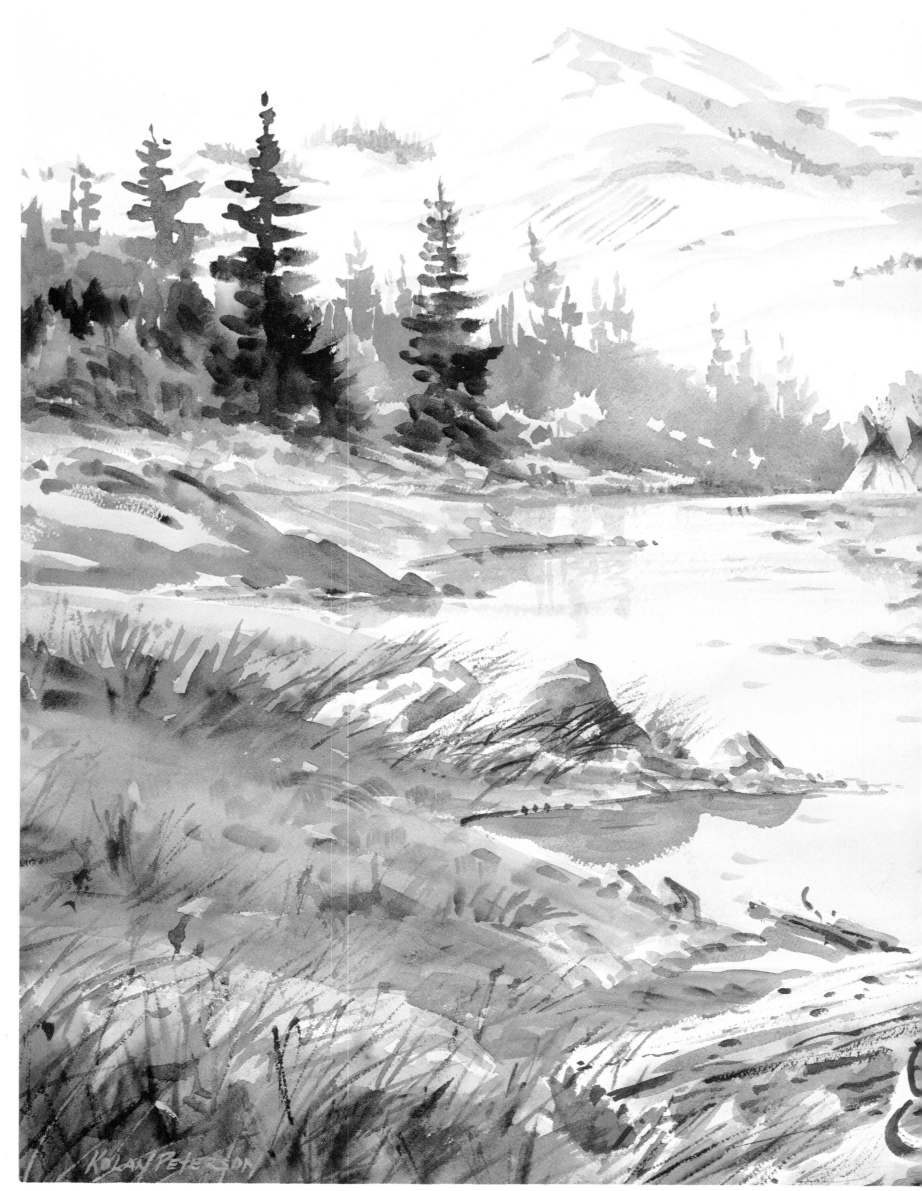

"SPRING ENCAMPMENT"

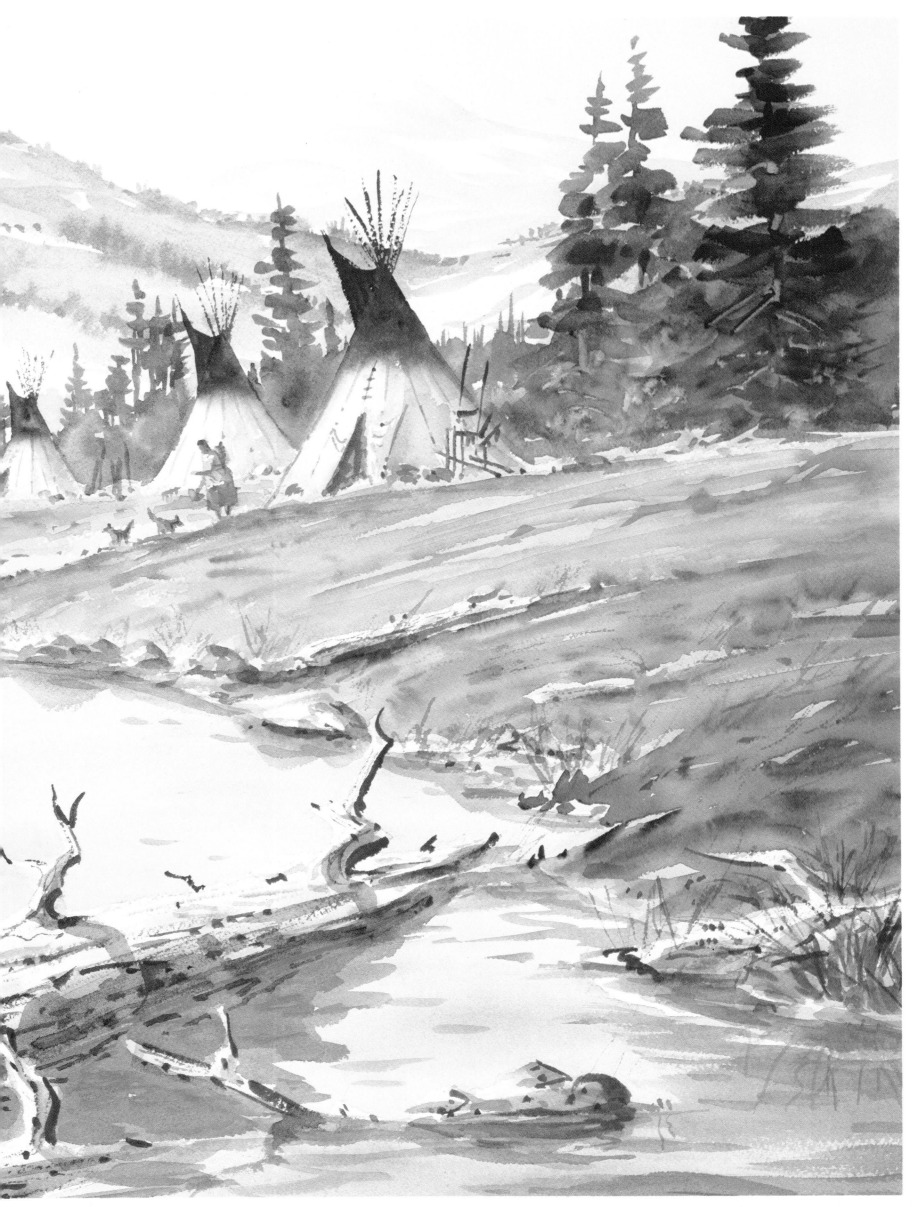

SKY: Cob. Blue

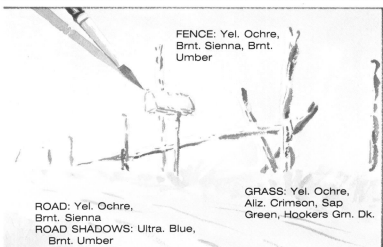

FENCE: Yel. Ochre, Brnt. Sienna, Brnt. Umber

GRASS: Yel. Ochre, Aliz. Crimson, Sap Green, Hookers Grn. Dk.

ROAD: Yel. Ochre, Brnt. Sienna
ROAD SHADOWS: Ultra. Blue, Brnt. Umber

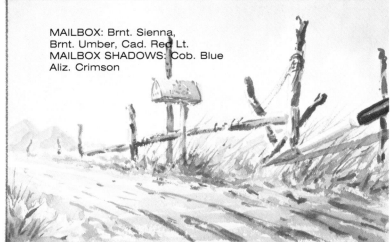

MAILBOX: Brnt. Sienna, Brnt. Umber, Cad. Red Lt.
MAILBOX SHADOWS: Cob. Blue Aliz. Crimson

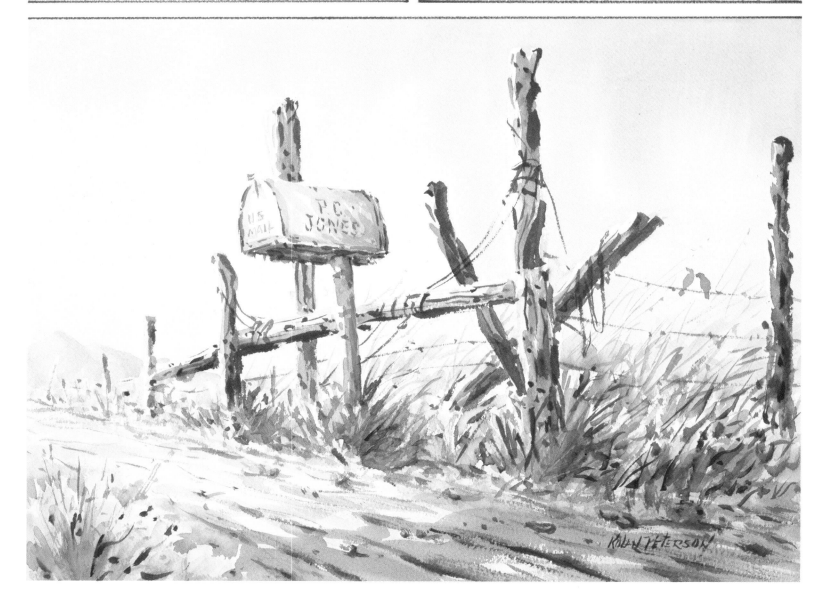

COUNTRY ROAD – You have probably passed mundane objects like beat-up mail boxes when you were looking for things to paint. R.C. Jones, whoever he is, had made the scene with this rendition of an old mailbox on a country road. Note that all features in picture lead to the object of interest. It's a simple and rustic treatment of an otherwise drab old thing – a mail box. The one inch brush will do the sky and foreground. Your round brush is used to add detail. Tip: do just one fence post on a scrap of paper and see how you make out. You'll do alright ultimately and you'll be pleased with yourself.

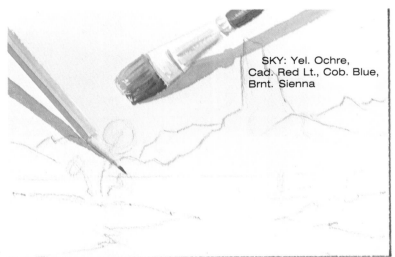

SKY: Yel. Ochre,
Cad. Red Lt., Cob. Blue,
Brnt. Sienna

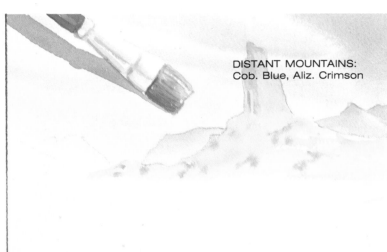

DISTANT MOUNTAINS:
Cob. Blue, Aliz. Crimson

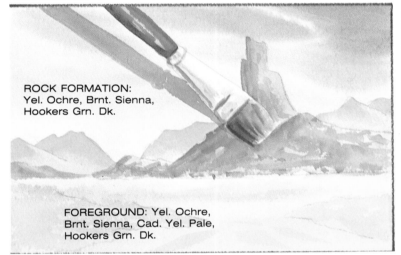

ROCK FORMATION:
Yel. Ochre, Brnt. Sienna,
Hookers Grn. Dk.

FOREGROUND: Yel. Ochre,
Brnt. Sienna, Cad. Yel. Pale,
Hookers Grn. Dk.

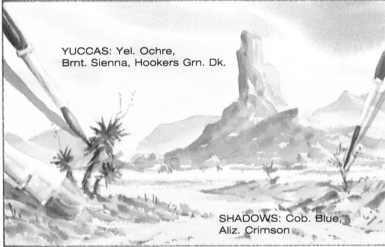

YUCCAS: Yel. Ochre,
Brnt. Sienna, Hookers Grn. Dk.

SHADOWS: Cob. Blue,
Aliz. Crimson

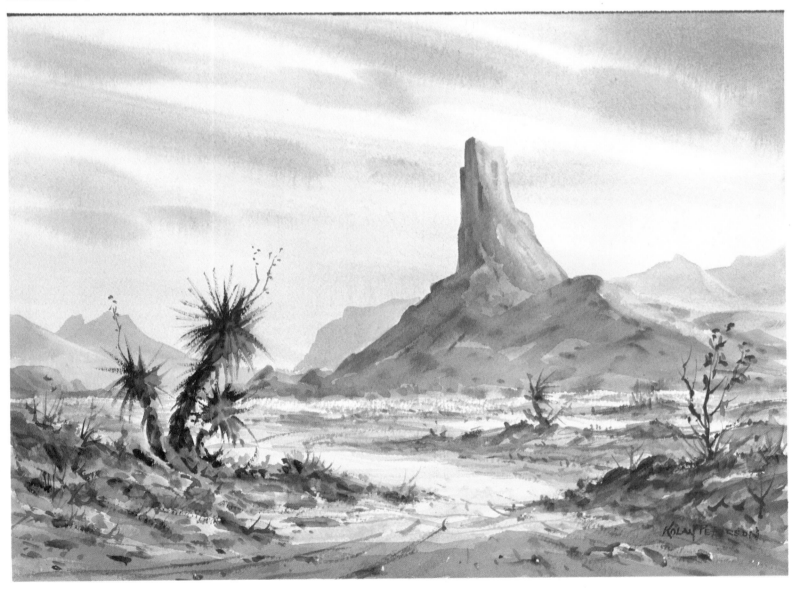

DESERT PANORAMA – A peak, a Yucca tree and a broad sweep of evening sky delights the heart of any nature lover. This picture "says" just enough and uses light areas at the base of the peaks to stress the darker areas. A conglomerate of colors add interest to the foreground floor. Dry brush strokes are used to form the Yucca. A rigger is used to paint the stalks and blossoms at the very top of the tree. Blue gray is used in distant mountains. This gives a feeling of depth. Darker and more detailed objects in foreground keep the middle ground tones in their proper value.

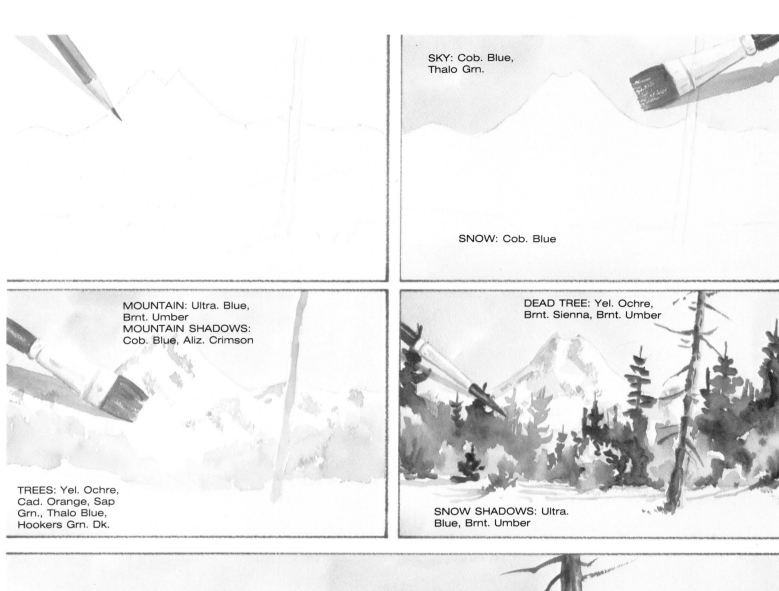

SKY: Cob. Blue, Thalo Grn.

SNOW: Cob. Blue

MOUNTAIN: Ultra. Blue, Brnt. Umber
MOUNTAIN SHADOWS: Cob. Blue, Aliz. Crimson

TREES: Yel. Ochre, Cad. Orange, Sap Grn., Thalo Blue, Hookers Grn. Dk.

DEAD TREE: Yel. Ochre, Brnt. Sienna, Brnt. Umber

SNOW SHADOWS: Ultra. Blue, Brnt. Umber

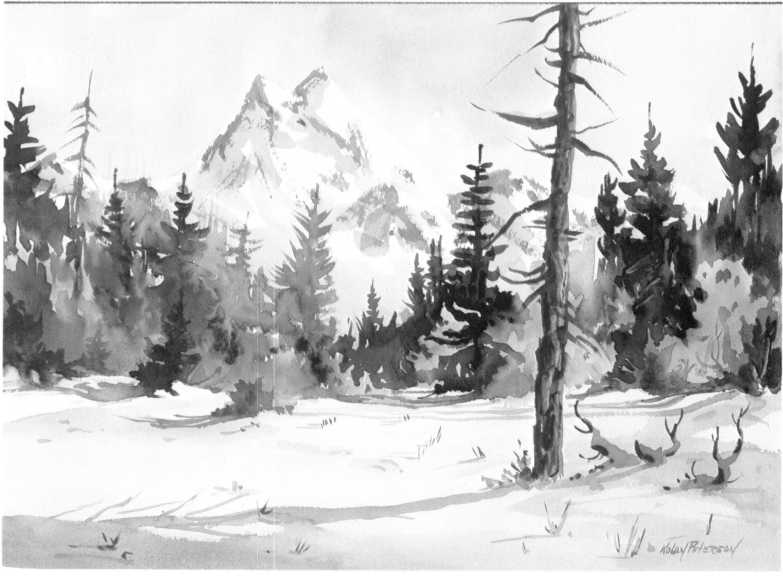

HIGH COUNTRY – Could be Utah – Could be Washington State. Mother Nature pushed up peaks like this so that artists could have something at which to marvel. Mountains in the high country are always thrust skyward by timberline. Snow and mountain treatment reflect light source from the right. Shadows on the snow, along with weeds and dead tree bring life to a lovely mountain view. Preceding pictures at top of page show step-by-step procedure.

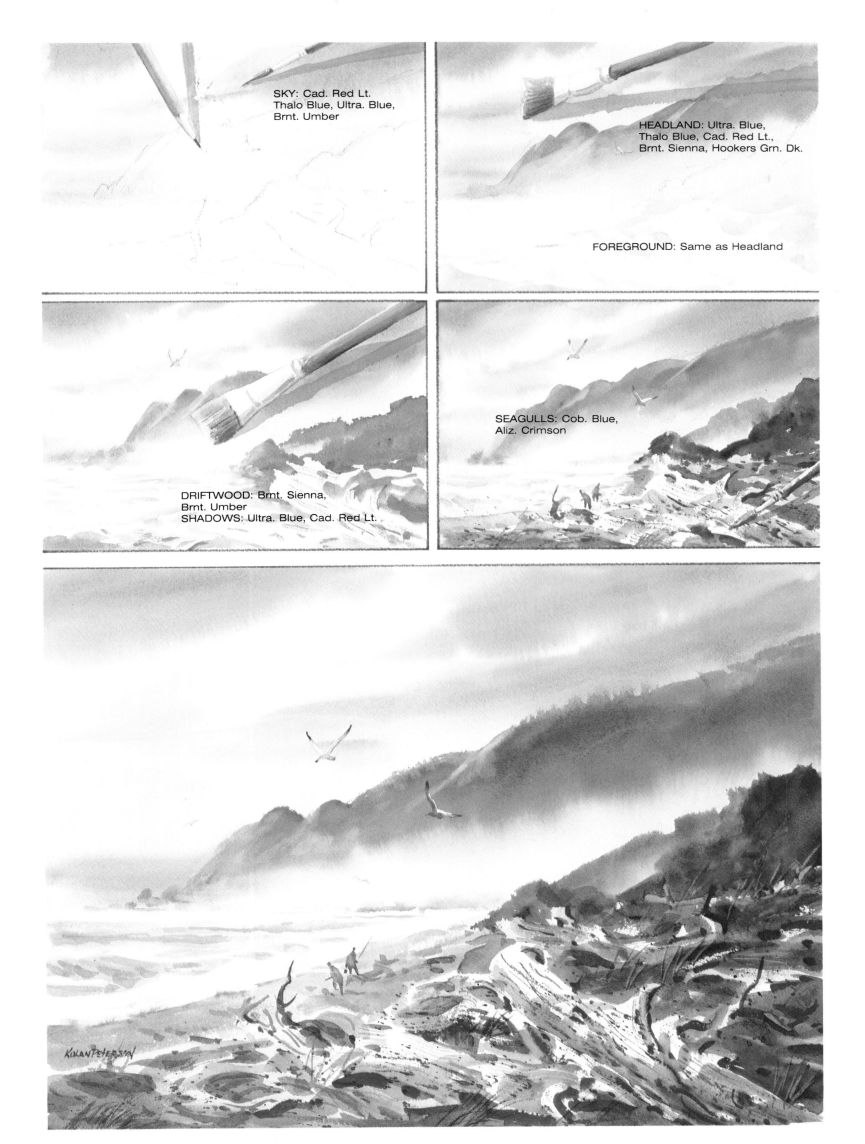

SKY: Cad. Red Lt.
Thalo Blue, Ultra. Blue,
Brnt. Umber

HEADLAND: Ultra. Blue,
Thalo Blue, Cad. Red Lt.,
Brnt. Sienna, Hookers Grn. Dk.

FOREGROUND: Same as Headland

DRIFTWOOD: Brnt. Sienna,
Brnt. Umber
SHADOWS: Ultra. Blue, Cad. Red Lt.

SEAGULLS: Cob. Blue,
Aliz. Crimson

CASCADE HEAD, OREGON – Oh yes! You can paint from slides and you can make vast improvements on the original. Painting the tons of driftwood is a challenge to the artist. Texture of the logs allows you to use the split brush procedure shown on page two. This is a good example of adding clear water to the wash at the base of the headland to give a misty look. The birds were masked out with liquid frisket before the washes were applied. After the paint was dry, the frisket was rubbed off and details were added.

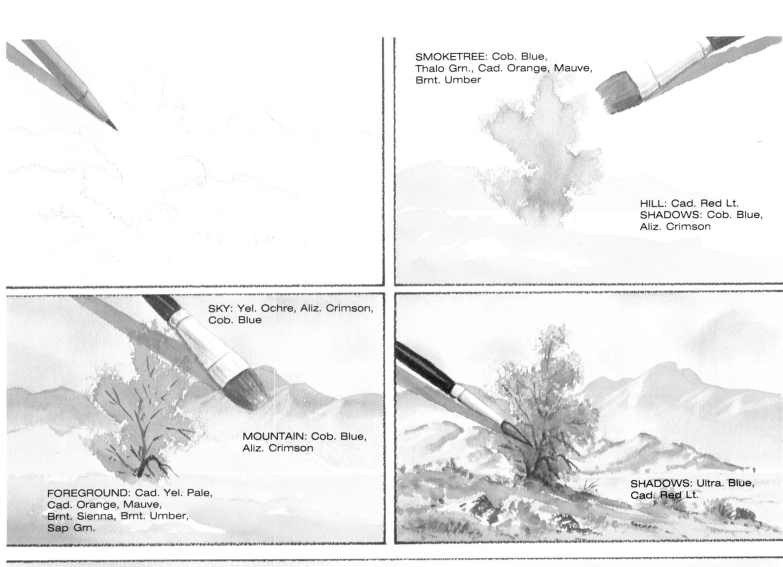

SMOKETREE: Cob. Blue,
Thalo Grn., Cad. Orange, Mauve,
Brnt. Umber

HILL: Cad. Red Lt.
SHADOWS: Cob. Blue,
Aliz. Crimson

SKY: Yel. Ochre, Aliz. Crimson,
Cob. Blue

MOUNTAIN: Cob. Blue,
Aliz. Crimson

FOREGROUND: Cad. Yel. Pale,
Cad. Orange, Mauve,
Brnt. Sienna, Brnt. Umber,
Sap Grn.

SHADOWS: Ultra. Blue,
Cad. Red Lt.

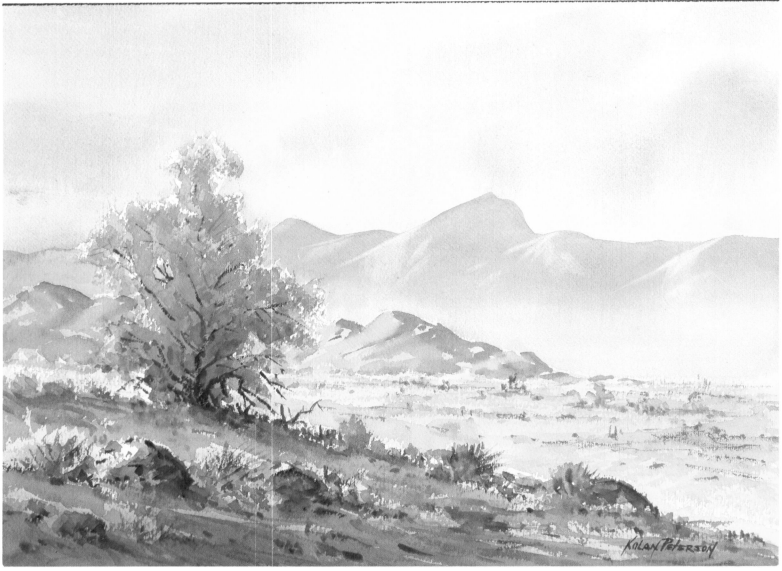

NEAR PALM SPRINGS, CALIFORNIA – If you like desert scenery, this smoke tree picture is for you. The completed picture was made from several photos taken in the Palm Springs area. Most of the foreground was painted in shadow in order to create a back light effect. The shadow color was painted around the trees and rocks and this left a sunlighted area. Use your round and rigger brushes to bring out the tree limbs and grasses. Notice that the trees are given a dark base to tie them to the ground.

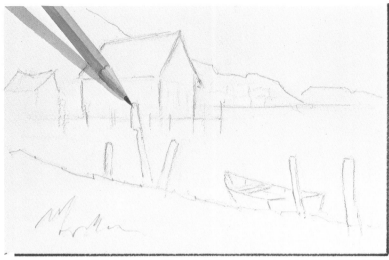

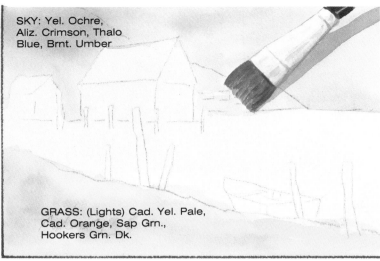

SKY: Yel. Ochre,
Aliz. Crimson, Thalo
Blue, Brnt. Umber

GRASS: (Lights) Cad. Yel. Pale,
Cad. Orange, Sap Grn.,
Hookers Grn. Dk.

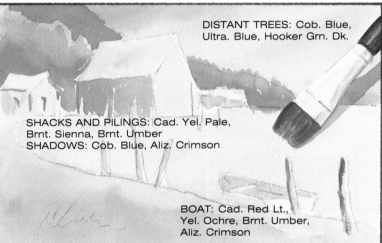

DISTANT TREES: Cob. Blue,
Ultra. Blue, Hooker Grn. Dk.

SHACKS AND PILINGS: Cad. Yel. Pale,
Brnt. Sienna, Brnt. Umber
SHADOWS: Cob. Blue, Aliz. Crimson

BOAT: Cad. Red Lt.,
Yel. Ochre, Brnt. Umber,
Aliz. Crimson

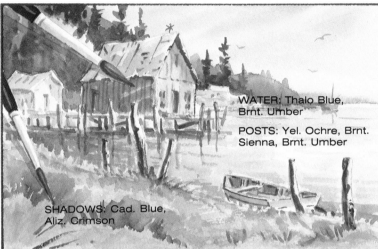

WATER: Thalo Blue,
Brnt. Umber

POSTS: Yel. Ochre, Brnt.
Sienna, Brnt. Umber

SHADOWS: Cad. Blue,
Aliz. Crimson

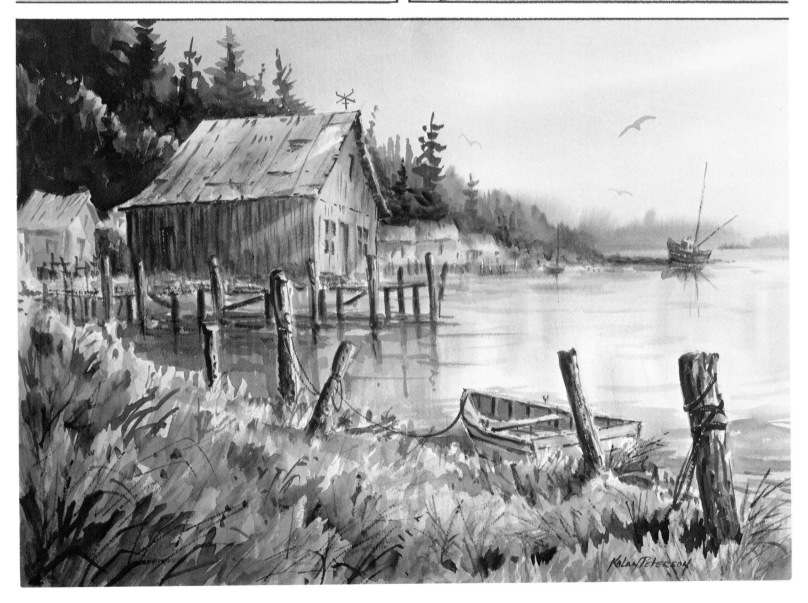

COASTAL INLET – You never paint a picture "all at once." You do your creation in planned steps. In the third step (above) light washes are used to establish areas that you wish to develop later on. By cutting in the trees around the top part of the building you make the roof stand out. All lines in the picture, even the boat and the pilings lead your eyes to the shack. The foreground uses light and dark contrasting grasses to bring out a pleasing effect. Posts, boat and reflections in the water give the painting a wet look.

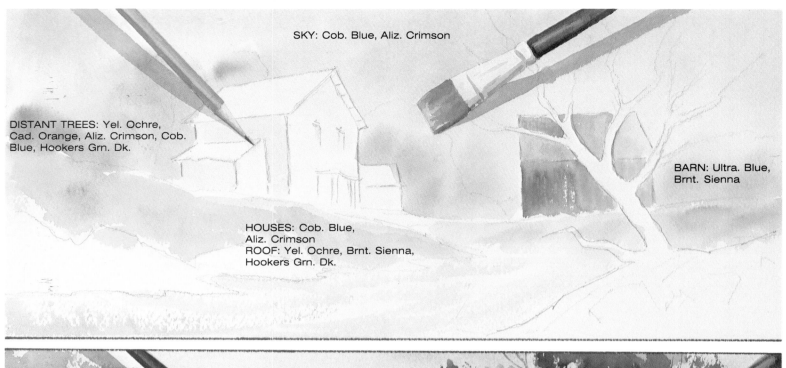

SKY: Cob. Blue, Aliz. Crimson

DISTANT TREES: Yel. Ochre, Cad. Orange, Aliz. Crimson, Cob. Blue, Hookers Grn. Dk.

BARN: Ultra. Blue, Brnt. Sienna

HOUSES: Cob. Blue, Aliz. Crimson
ROOF: Yel. Ochre, Brnt. Sienna, Hookers Grn. Dk.

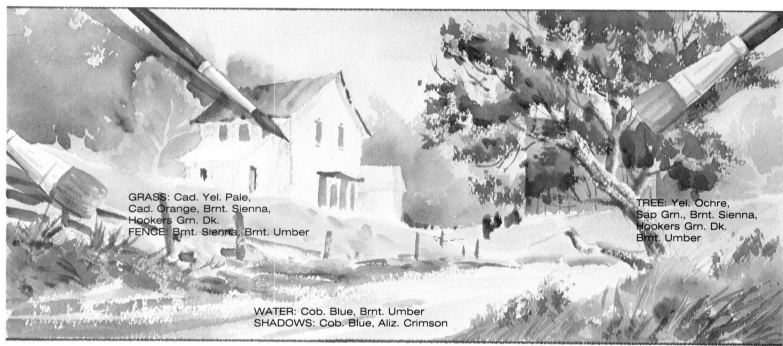

GRASS: Cad. Yel. Pale, Cad. Orange, Brnt. Sienna, Hookers Grn. Dk.
FENCE: Brnt. Sienna, Brnt. Umber

TREE: Yel. Ochre, Sap Grn., Brnt. Sienna, Hookers Grn. Dk. Brnt. Umber

WATER: Cob. Blue, Brnt. Umber
SHADOWS: Cob. Blue, Aliz. Crimson

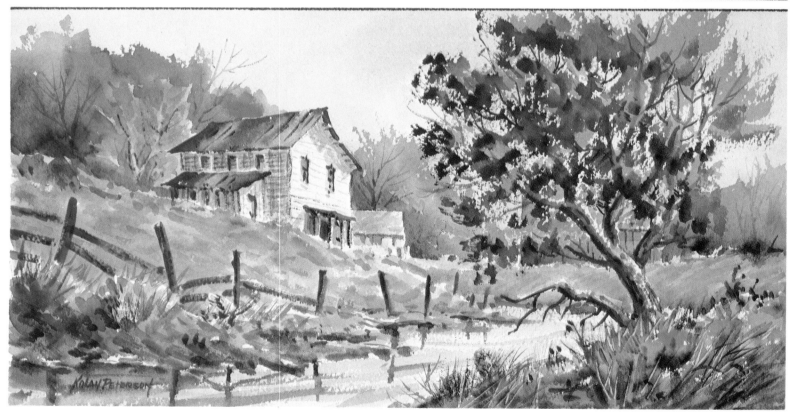

SEPTEMBER TIME – Autumn brings out nature's finest colors. Here, under a blue sky I framed the old white house with oranges, yellows and reds. Notice how I cut in the trees around the house. The hill in the foreground is made to slope down to the stream. The tree in the right foreground was painted with dark foliage to bring the viewer's eye to the old home, which of course, is the center of interest. Light blades in the grasses were scraped with a knife. The trunk of tree was painted so that the white of the paper stood out against the darker bark to bring roundness to the trunk.

SKY: Yel. Ochre, Ultra. Blue, Cad. Red Lt.

WINDMILL: Cob. Blue, Cad. Red Lt., Brnt. Sienna, Brnt. Umber

BUILDINGS: Yel. Ochre, Brnt. Sienna, Ultra. Blue

HILLS: Yel. Ochre, Ultra. Blue, Cad. Red Lt.

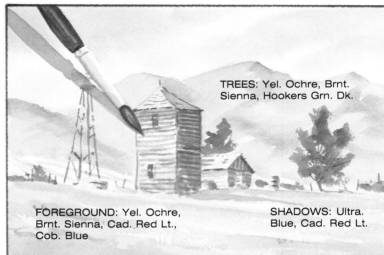

TREES: Yel. Ochre, Brnt. Sienna, Hookers Grn. Dk.

FOREGROUND: Yel. Ochre, Brnt. Sienna, Cad. Red Lt., Cob. Blue

SHADOWS: Ultra. Blue, Cad. Red Lt.

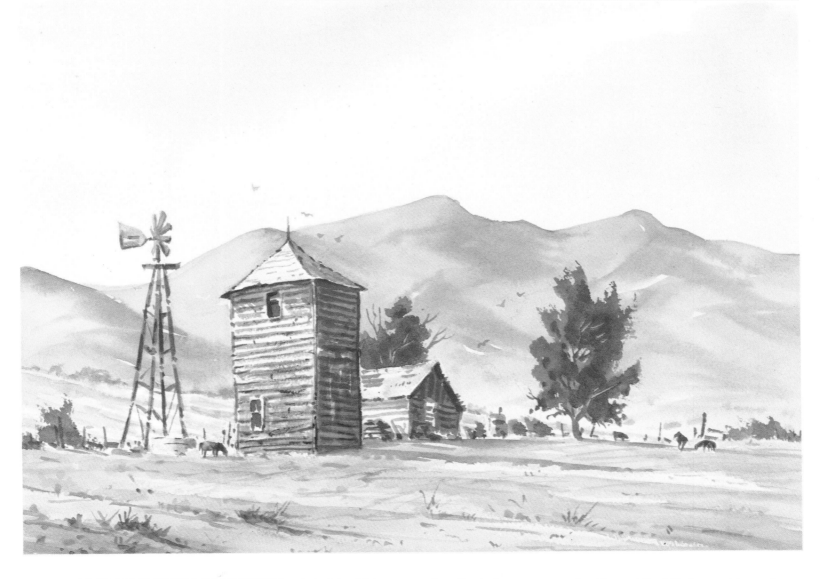

SUMMER IN NORTHERN CALIFORNIA – I sketched this scene when the hot summer sun had turned the hills to a golden yellow. This is a picture that employs the contrasts of darks and lights. The two story structure is of frame construction as is the barn in the background. They are painted dark to bring them forward in the picture. The tree, the cattle – each tends to bring out depth. Notice how the windmill points toward the center of interest. Cows and horses add life to the picture. Note also that the blues in the roofs were carried over to the water tank. This was done to add cool tones against the hot summer colors.

25

SKY: Yel. Ochre, Thalo Grn., Ultra. Blue, Brnt. Umber

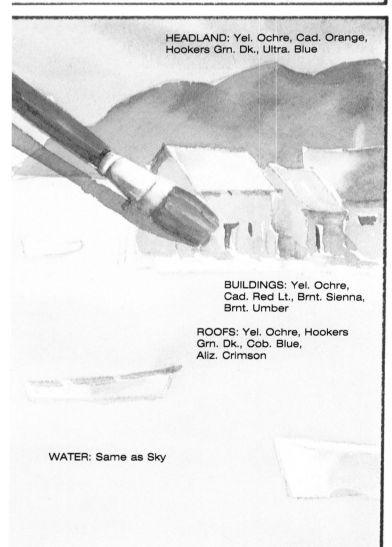

HEADLAND: Yel. Ochre, Cad. Orange, Hookers Grn. Dk., Ultra. Blue

BUILDINGS: Yel. Ochre, Cad. Red Lt., Brnt. Sienna, Brnt. Umber

ROOFS: Yel. Ochre, Hookers Grn. Dk., Cob. Blue, Aliz. Crimson

WATER: Same as Sky

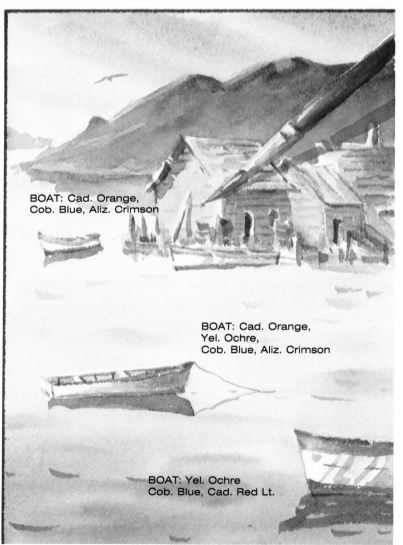

BOAT: Cad. Orange, Cob. Blue, Aliz. Crimson

BOAT: Cad. Orange, Yel. Ochre, Cob. Blue, Aliz. Crimson

BOAT: Yel. Ochre Cob. Blue, Cad. Red Lt.

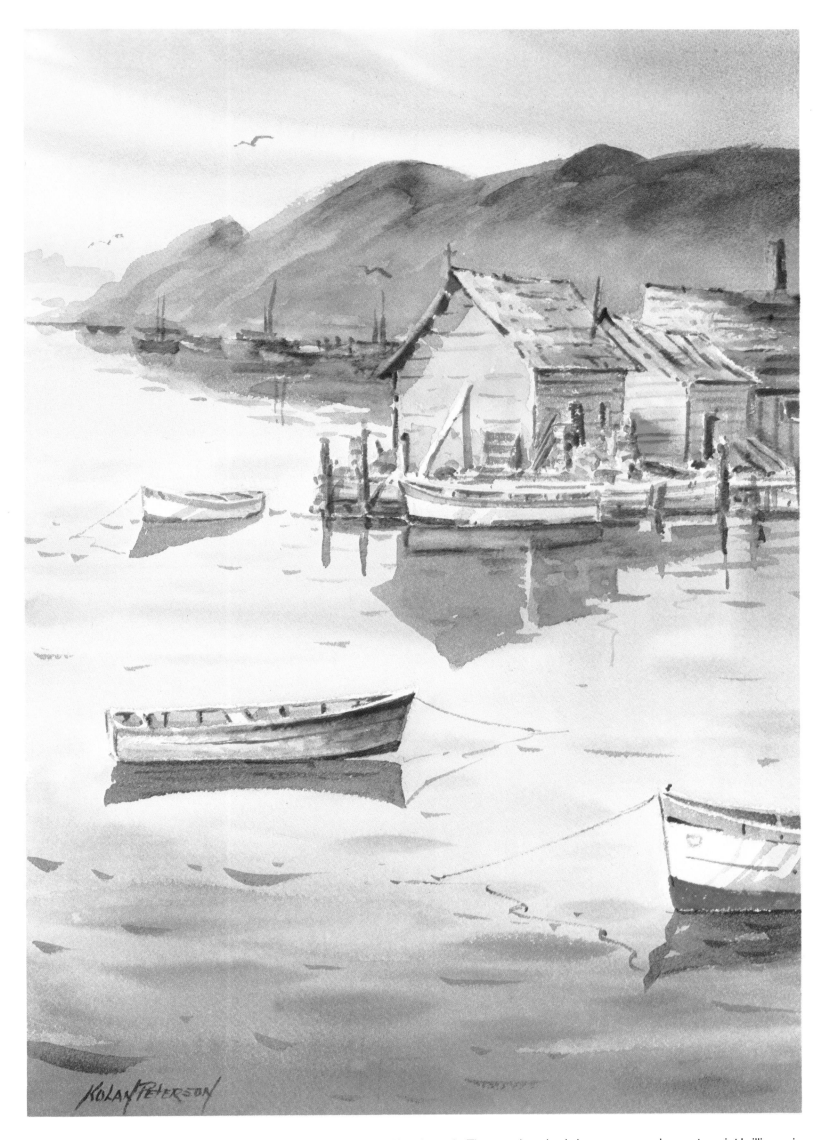

COASTAL REFLECTIONS – Early morning with the sun breaking through. The sun drenched sky gave me a chance to paint brilliance in the buildings and the harbor reflections. Keep the water transparent. Paint in reflections and add a few ripples to give the water a sense of movement. The darker shades in the foreground forces the viewer's eye up towards the shacks, which are of course, the center of interest. Boats and sea gulls bring the feeling of life.

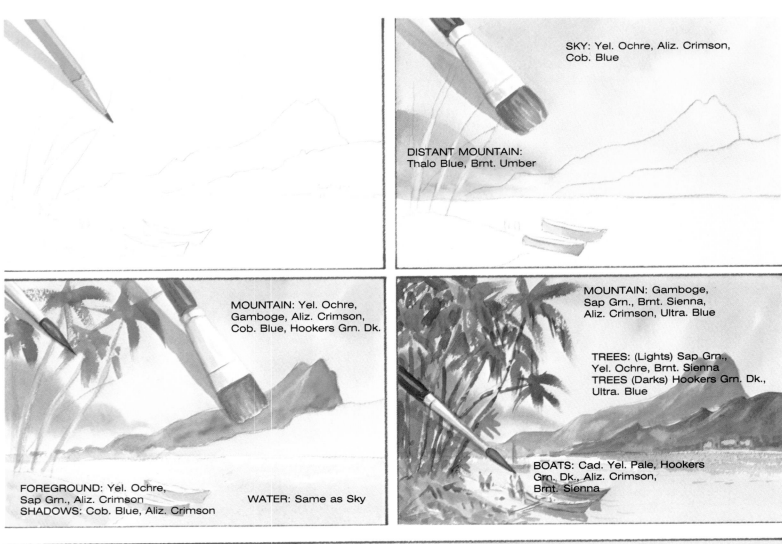

SKY: Yel. Ochre, Aliz. Crimson, Cob. Blue

DISTANT MOUNTAIN: Thalo Blue, Brnt. Umber

MOUNTAIN: Yel. Ochre, Gamboge, Aliz. Crimson, Cob. Blue, Hookers Grn. Dk.

FOREGROUND: Yel. Ochre, Sap Grn., Aliz. Crimson
SHADOWS: Cob. Blue, Aliz. Crimson

WATER: Same as Sky

MOUNTAIN: Gamboge, Sap Grn., Brnt. Sienna, Aliz. Crimson, Ultra. Blue

TREES: (Lights) Sap Grn., Yel. Ochre, Brnt. Sienna
TREES (Darks) Hookers Grn. Dk., Ultra. Blue

BOATS: Cad. Yel. Pale, Hookers Grn. Dk., Aliz. Crimson, Brnt. Sienna

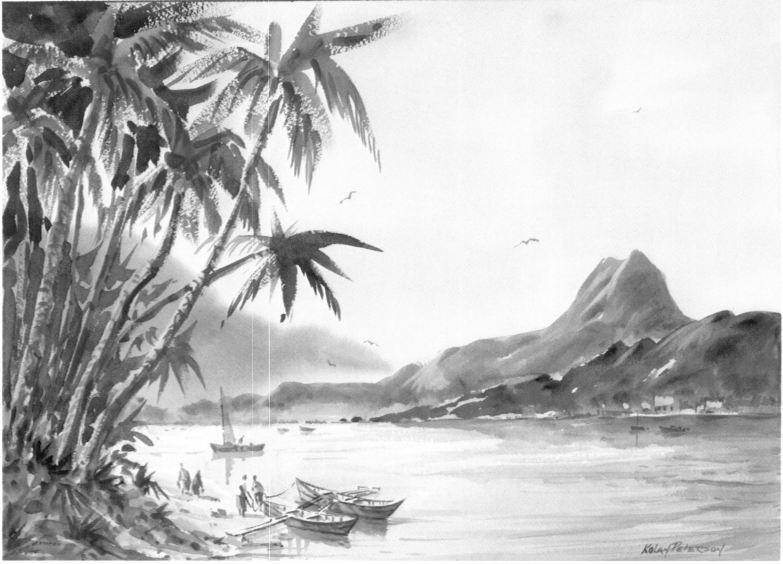

PALMS AND BEACH – Your center of interests: the palms and people at the left of the picture. From here they could be sailing off to the islands – perhaps visiting friends in homes across the way. This picture allows you to use lots of colors that are actually blended on the wet paper. The mountains to the right point to the activity on the beach. I achieved "roundness" of the palm tree trunks with a few curved lines.

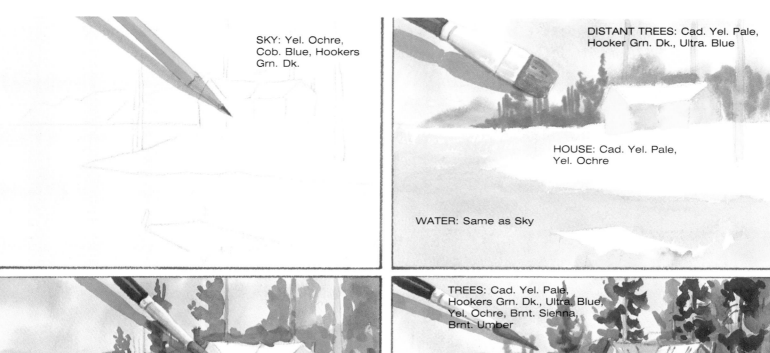

SKY: Yel. Ochre,
Cob. Blue, Hookers
Grn. Dk.

DISTANT TREES: Cad. Yel. Pale,
Hooker Grn. Dk., Ultra. Blue

HOUSE: Cad. Yel. Pale,
Yel. Ochre

WATER: Same as Sky

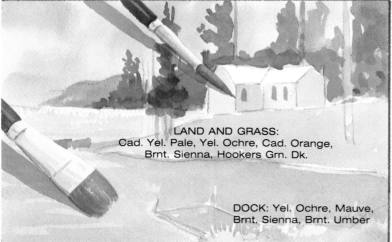

LAND AND GRASS:
Cad. Yel. Pale, Yel. Ochre, Cad. Orange,
Brnt. Sienna, Hookers Grn. Dk.

DOCK: Yel. Ochre, Mauve,
Brnt. Sienna, Brnt. Umber

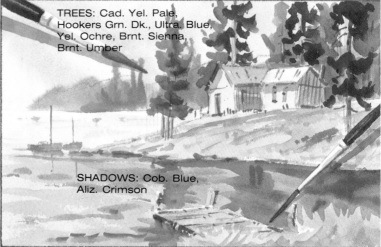

TREES: Cad. Yel. Pale,
Hookers Grn. Dk., Ultra. Blue,
Yel. Ochre, Brnt. Sienna,
Brnt. Umber

SHADOWS: Cob. Blue,
Aliz. Crimson

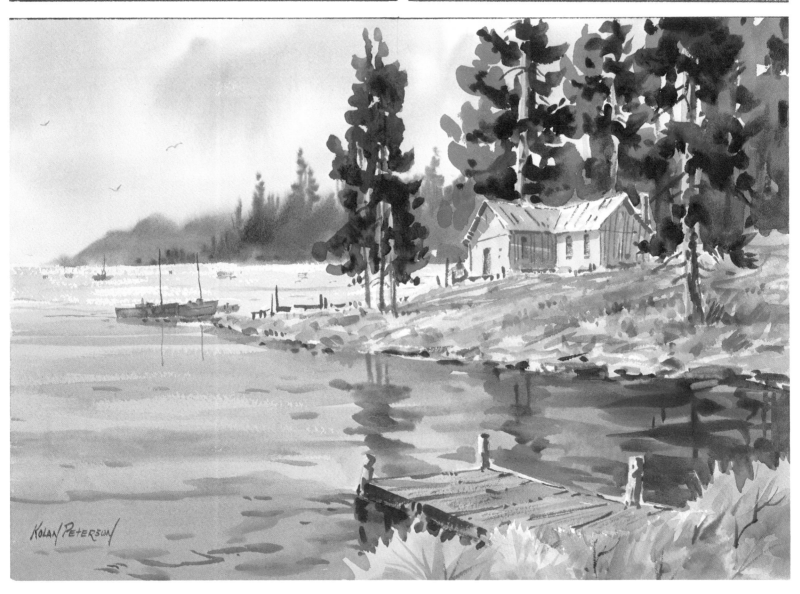

FABULOUS BIG BEAR, CALIFORNIA – There's skiing in winter – cool winds for leisure living during hot California summers. More to the point, the kind people who live in this cabin purchased a sketch similar to this painting. Dry brush achieves the shimmer of water against the distant shore. Apply darker colors with a "loaded" brush to bring out reflections in the water in the foreground. Reddish-yellow dock brings contrast. Bushes overlap the dock. This effect was achieved by painting water reflections around them. This creation invites you to fish, doesn't it? Let's make an observation. The bushes around the dock soften hard lines, direct eyes upward.

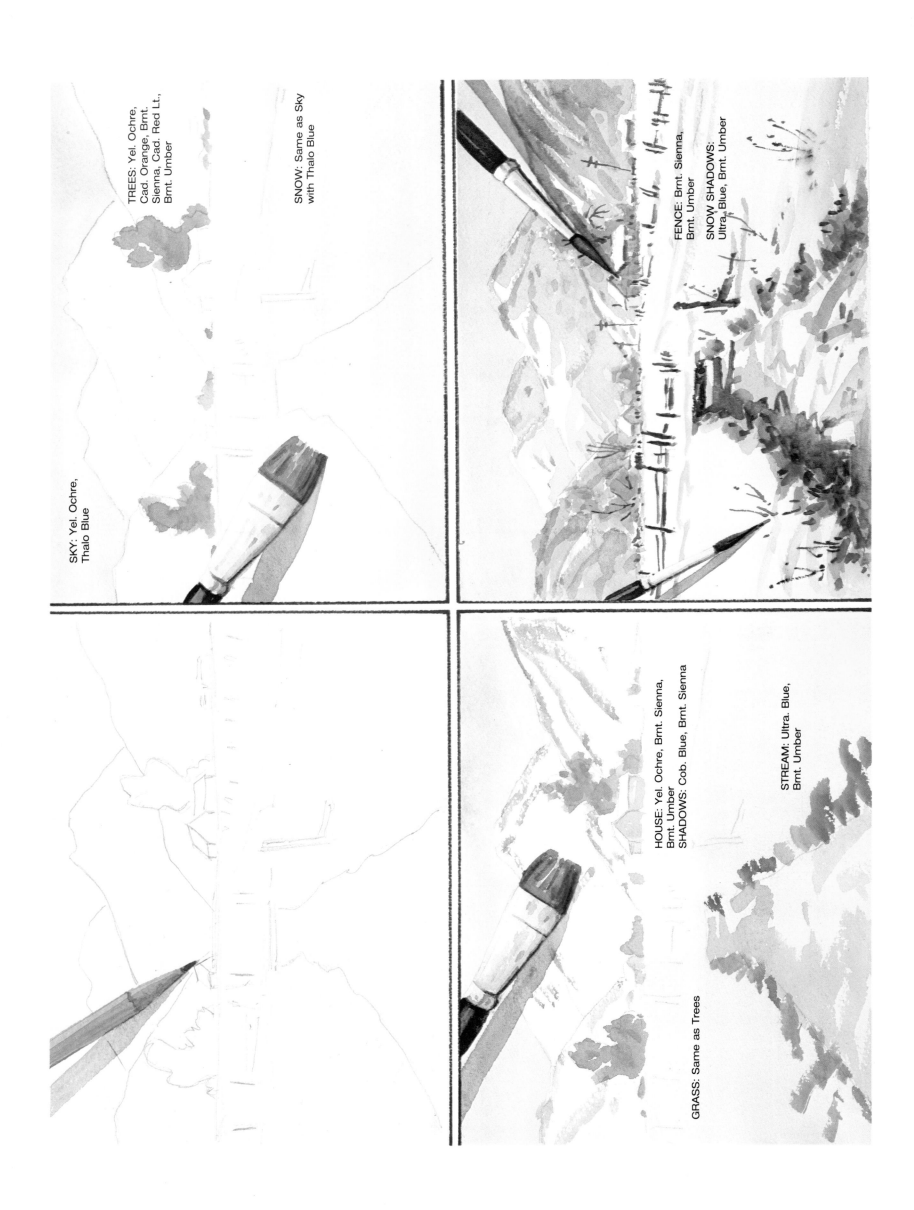

SKY: Yel. Ochre,
Thalo Blue

TREES: Yel. Ochre,
Cad. Orange, Brnt.
Sienna, Cad. Red Lt.,
Brnt. Umber

SNOW: Same as Sky
with Thalo Blue

FENCE: Brnt. Sienna,
Brnt. Umber

SNOW SHADOWS:
Ultra. Blue, Brnt. Umber

HOUSE: Yel. Ochre, Brnt. Sienna,
Brnt. Umber
SHADOWS: Cob. Blue, Brnt. Sienna

STREAM: Ultra. Blue,
Brnt. Umber

GRASS: Same as Trees

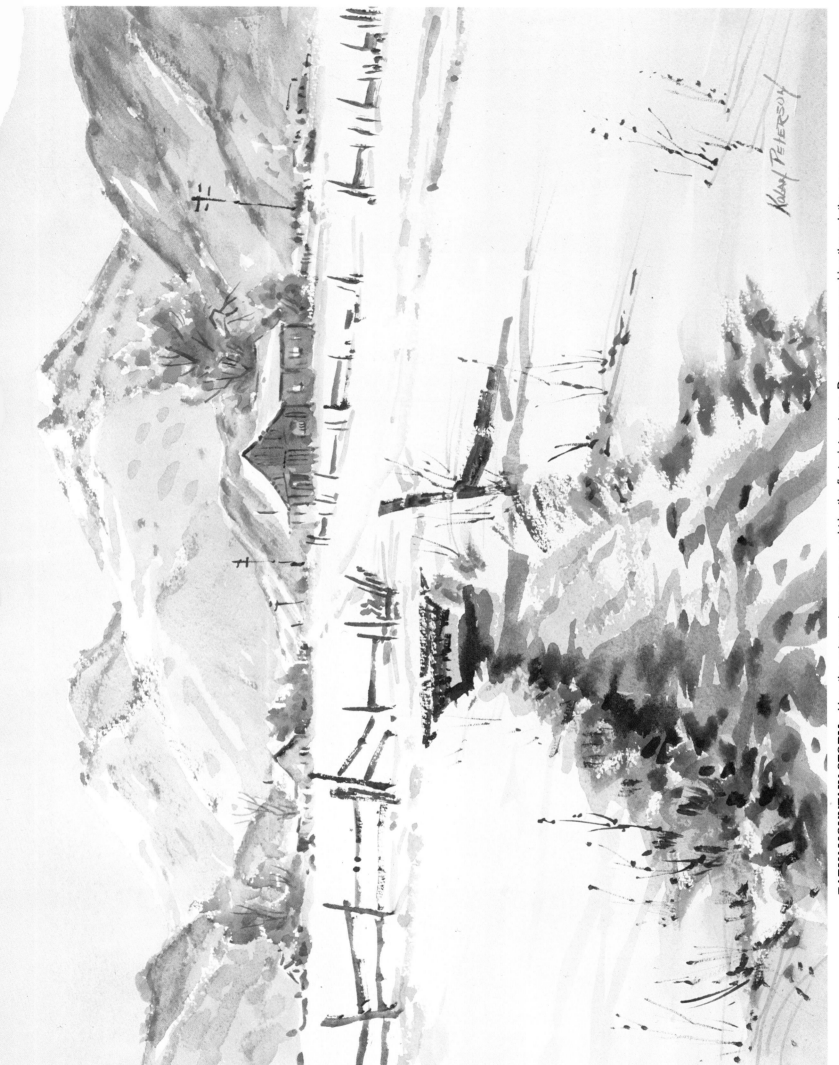

EARLY MOUNTAIN STORM – Here the autumn trees were caught by the first winter storm. Dry grasses are peeking through the snow. The blues and violets make the complimentary orange color seem more intense. Always tone the snow with a light wet wash. You can add shadows after the wash has dried. Now top off the stream bank with weeds. You will use your small brush for detail. Lights show from the windows to establish the feeling of early morning. Fences point the way to adventures in the mountains.

More Ways to Learn

Artist's Library

AL26 · AL04 · AL02

The **Artist's Library** series offers both beginning and advanced artists many opportunities to expand their creativity, conquer technical obstacles, and explore new media. You'll find in-depth, thorough information on each subject or art technique featured in the book. Each book is written and illustrated by a well-known artist who is qualified to help take eager learners to a new level of expertise.

Paperback, 64 pages, 6-1/2" x 9-1/2"

Collector's Series

CS01 · CS03 · CS02

Collector's Series books are excellent additions to any library, offering a comprehensive selection of projects drawn from the most popular titles in our How to Draw and Paint series. These books take the fundamentals of a particular medium, then further explore the subjects, styles, and techniques of featured artists.

CS01, CS02, CS04: Paperback, 144 pages, 9" x 12"
CS03: Paperback, 224 pages, 10-1/4" x 9"

How to Draw and Paint

HT264 · HT265 · HT266 · HT268

The **How to Draw and Paint** series includes these five stunning new titles to enhance an extensive collection of books on every subject and medium to meet any artist's needs. Specially written to encourage and motivate, these new books offer essential information in an easy-to-follow format. Lavishly illustrated with beautiful drawings and gorgeous art, this series both instructs and inspires.

Paperback, 32 pages, 10-1/4" x 13-3/4"

Walter Foster products are available at art and craft stores everywhere. Write or call for a FREE catalog that includes all of Walter Foster's titles. Or visit our website at www.walterfoster.com

Walter Foster™

Walter Foster Publishing, Inc. • 23062 La Cadena Drive • Laguna Hills, CA 92653 • (800) 426-00